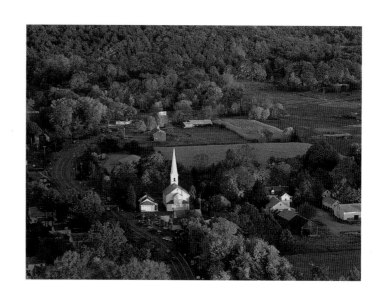

MASSACHUSETTS

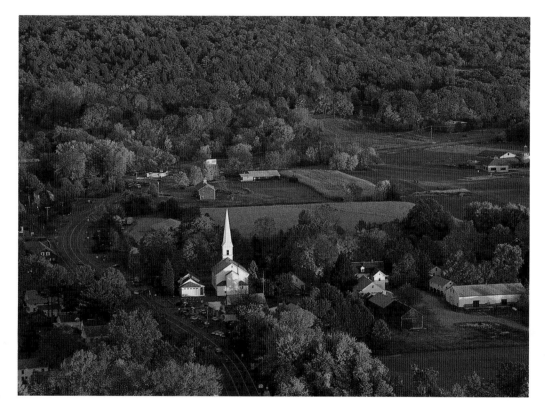

WHITECAP BOOKS
VANCOUVER / TORONTO / NEW YORK

Text by Tanya Lloyd
Edited by Elaine Jones
Photo editing by Tanya Lloyd
Proofread by Lisa Collins
Cover and interior design by Maxine Lea

Printed and bound in Canada

National Library of Canada Cataloguing in Publication Data

Lloyd, Tanya, 1973–

 Massachusetts

 (America series)
 ISBN 1-55285-178-8

 1. Massachusetts—Pictorial works. I. Title. II. Series: Lloyd, Tanya,
1973- America series.
F65.L56 2001 974.4'044'0222 C2001-910267-4

The publisher acknowledges the support of the Canada Council and the Cultural
Services Branch of the Government of British Columbia in making this publication
possible. We acknowledge the financial support of the Government of Canada through
the Book Publishing Industry Development Program for our publishing activities.

For more information on the America Series and other Whitecap Books
titles, please visit our web site at www.whitecap.ca.

W andering the port-side streets and mountain villages of Massachusetts brings reminder after reminder that this is the birthplace of a nation. Almost five hundred years ago, the Pilgrims sailed into Plymouth's harbor and began forging a new way of life. By the late 1700s, the colony they founded was ready to break its ties with Britain and begin life as the United States of America.

The country's birth may be long past, but its memory lingers at every turn in Massachusetts. Boston Harbor, where colonists dumped imported tea overboard to protest taxing; the route from Boston to Concord, where Paul Revere made his now-famous ride to warn of British attack; the Bunker Hill Monument, site of a Revolutionary War battle – each step is a milestone in American history. Evacuation Day, when the British soldiers left America, is still remembered in parts of Massachusetts, and sightseers learn that George Washington toasted America's first birthday from Boston's Faneuil Hall.

Of course, the state is not all historical sites and commemorative plaques. From fishing villages on the northern coast and whale-watching vessels at Cape Cod to church steeples and mountain spires in the Berkshires, the beauty of the landscape and the lively events of daily life inspired literary greats such as Ralph Waldo Emerson and Henry David Thoreau.

With almost half of New England's population settled within Massachusetts' borders, there is a new neighborhood at every turn, from the second-hand bookshops of Cambridge to the office towers and busy streets of Worcester. And each step, along the boardwalks of the coastal towns or the wooded paths of the mountain parks, offers new adventures to be found.

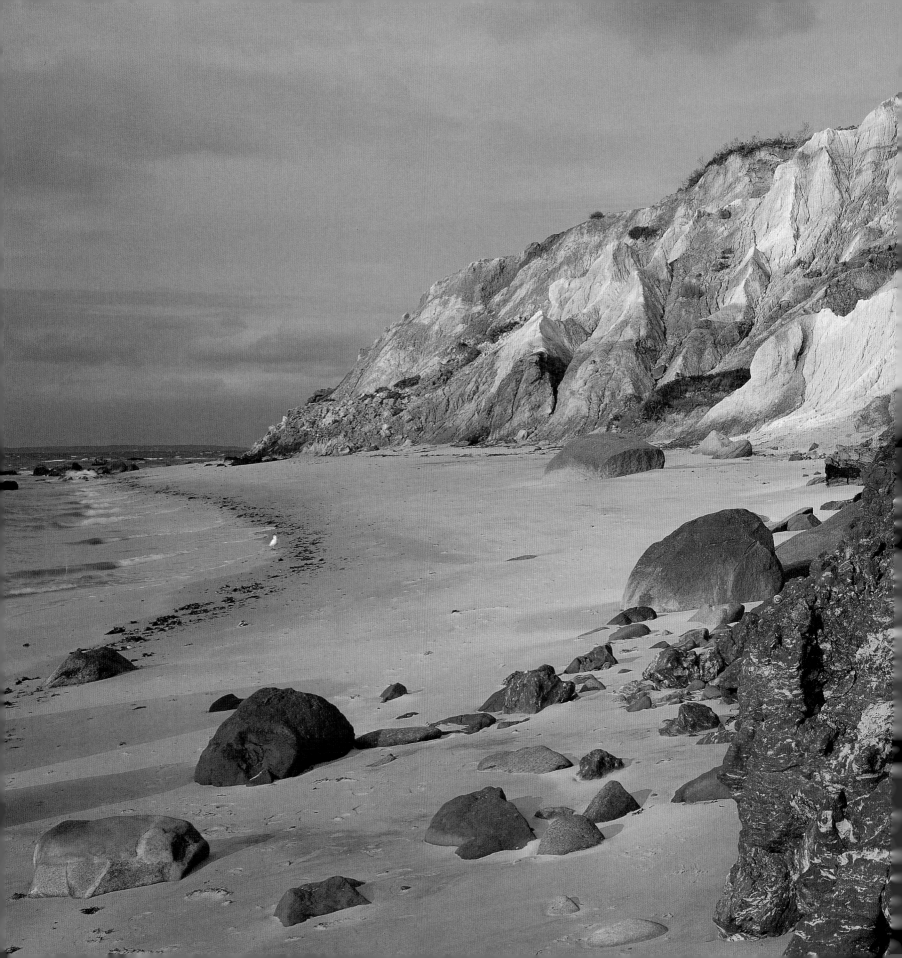

Glaciers carved
Martha's Vineyard
from the mainland
about 10,000 years
ago. Just 23 miles
long, the island has
almost 125 miles
of shoreline, with
white sand beaches
and rugged cliffs.

7

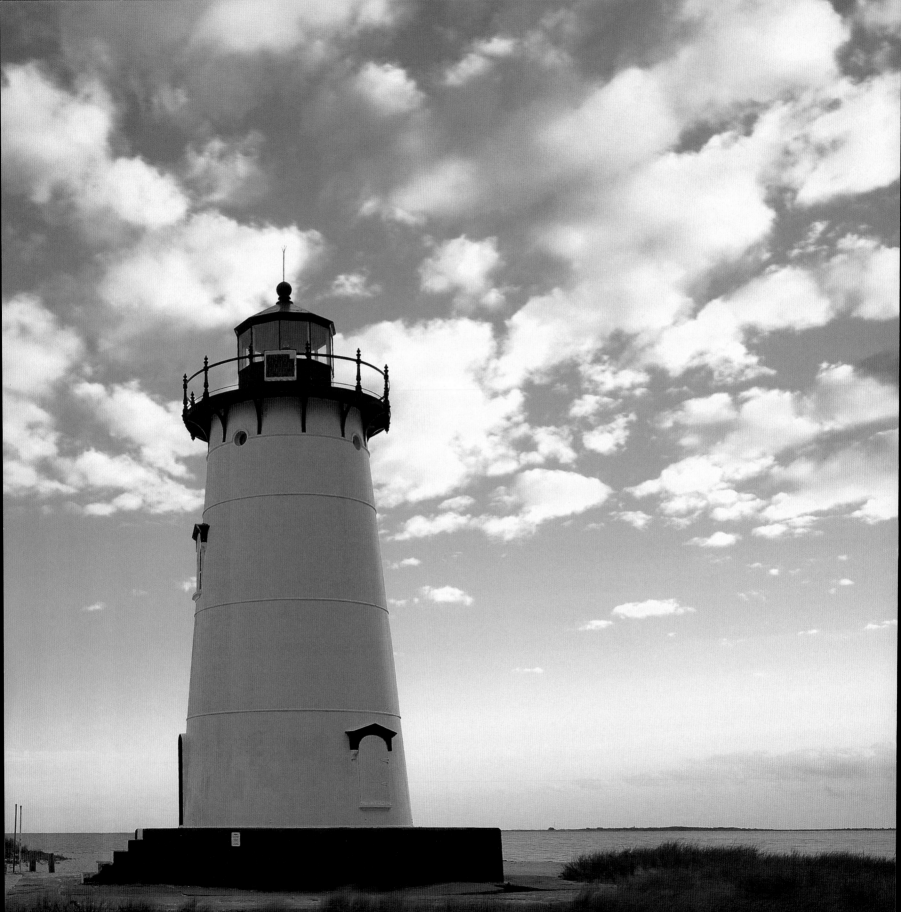

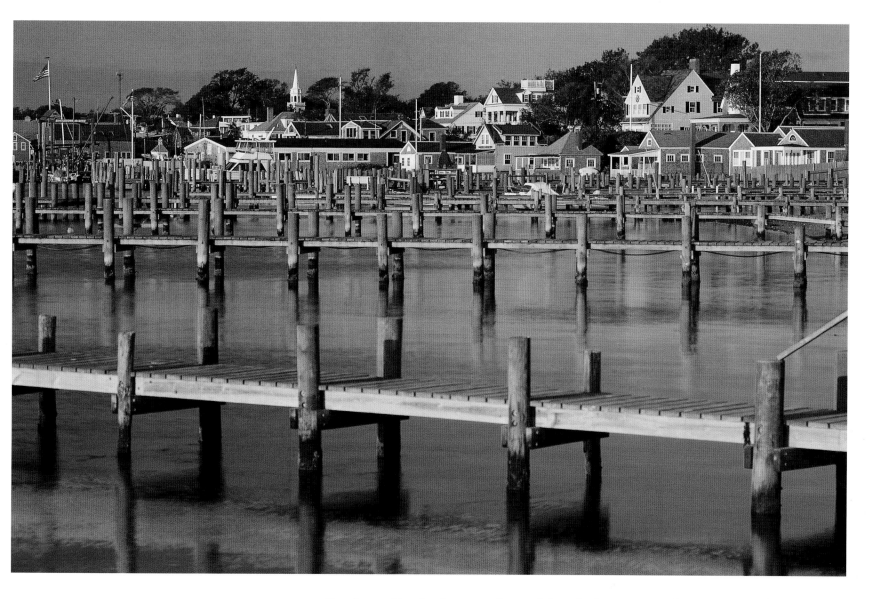

Explorer Bartholomew Gosnold sailed past Martha's Vineyard in 1602.
He named the island for one of his daughters, Martha, and for the
profusion of wild grapes blooming there.

Connected to the shore by a thin strip of land, the Edgartown
Lighthouse was built in 1938 in Ipswich and brought to Martha's
Vineyard by raft. It replaced an earlier structure that had stood
on the island for more than a century.

9

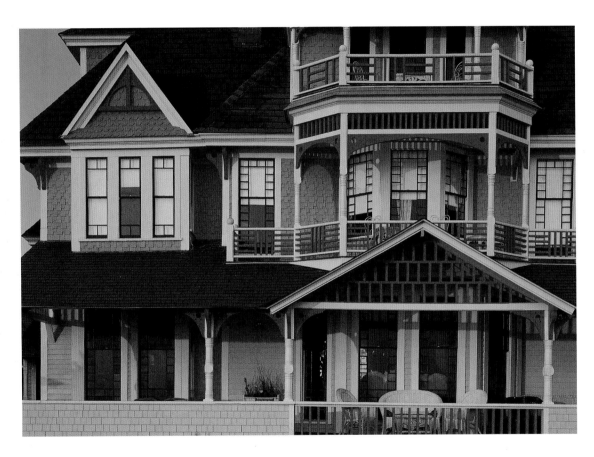

Enthusiasts flocked to Martha's Vineyard for revival-style religious meetings in the late 1700s and early 1800s. They first constructed tents, then platforms, then elaborately decorated cottages. The gingerbread style was eventually copied by the island's wealthier residents, and the homes still stand today.

The first European settlers on the island of Nantucket arrived in 1659, seeking relief from the strict standards of the Massachusetts Bay Colony. A strong Quaker settlement later developed here.

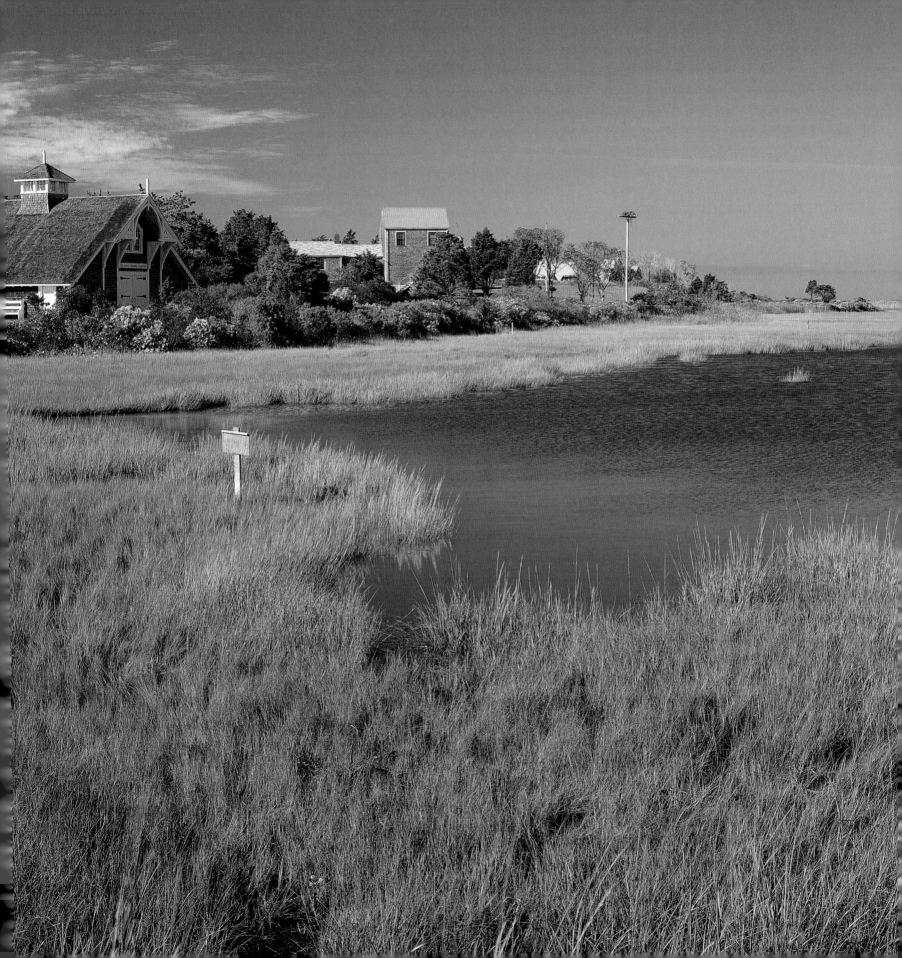

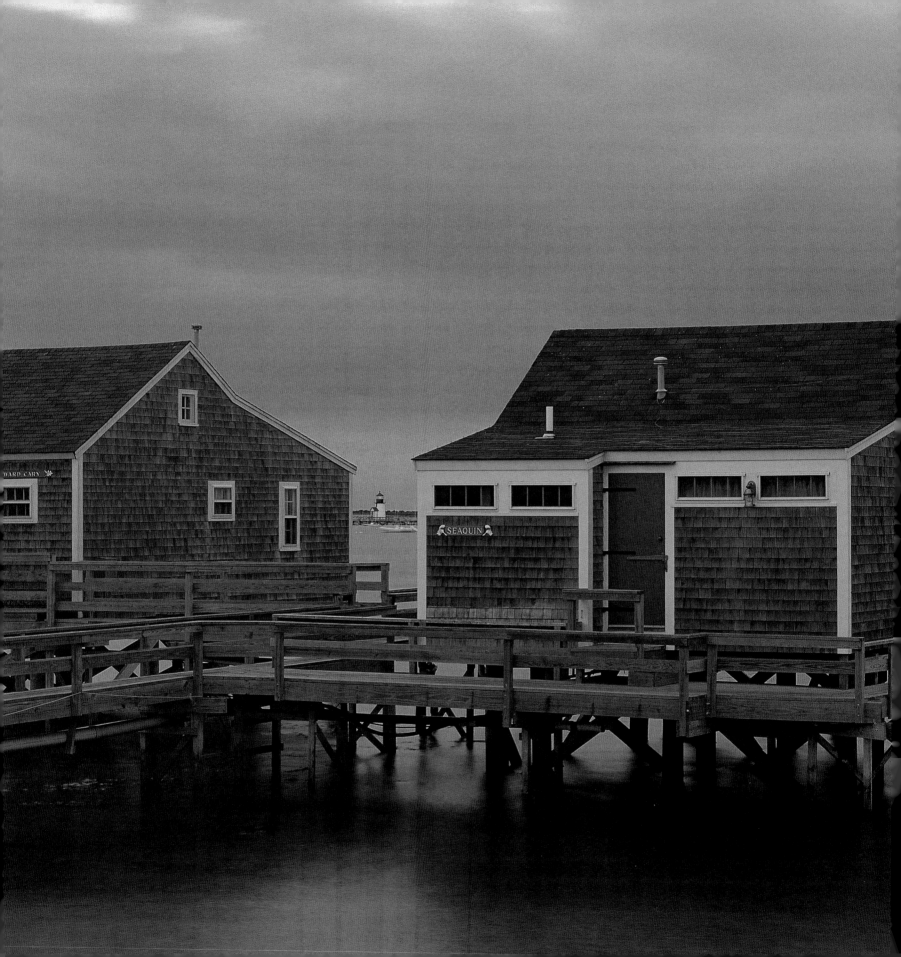

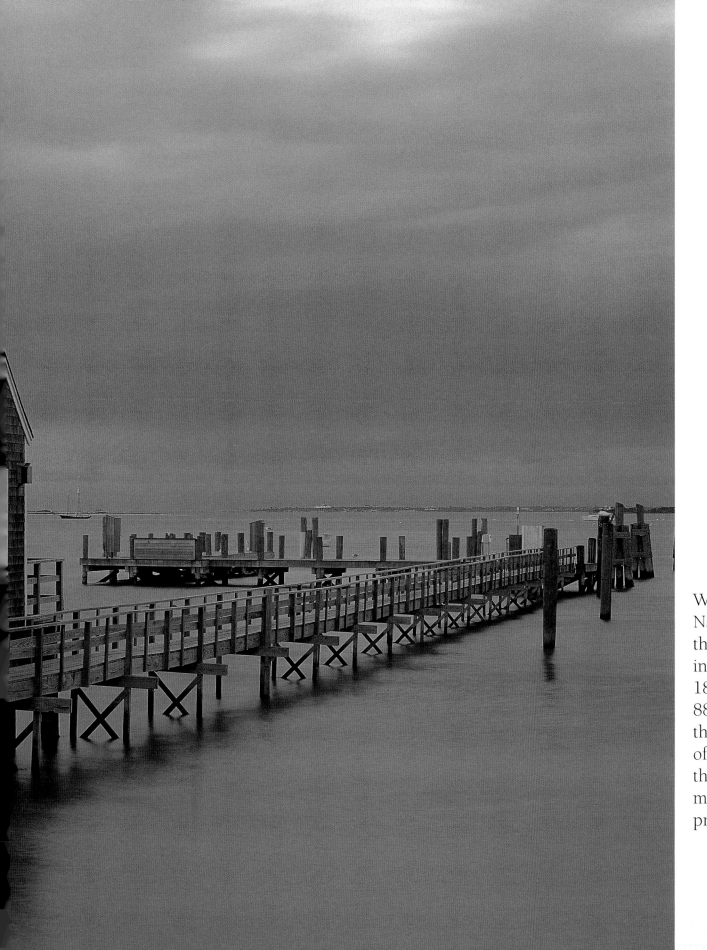

Whaling boomed in Nantucket for more than a century, reaching its peak between 1800 and 1840. With 88 ships, this was the whaling capital of the world and the industry's gains made the island a prosperous one.

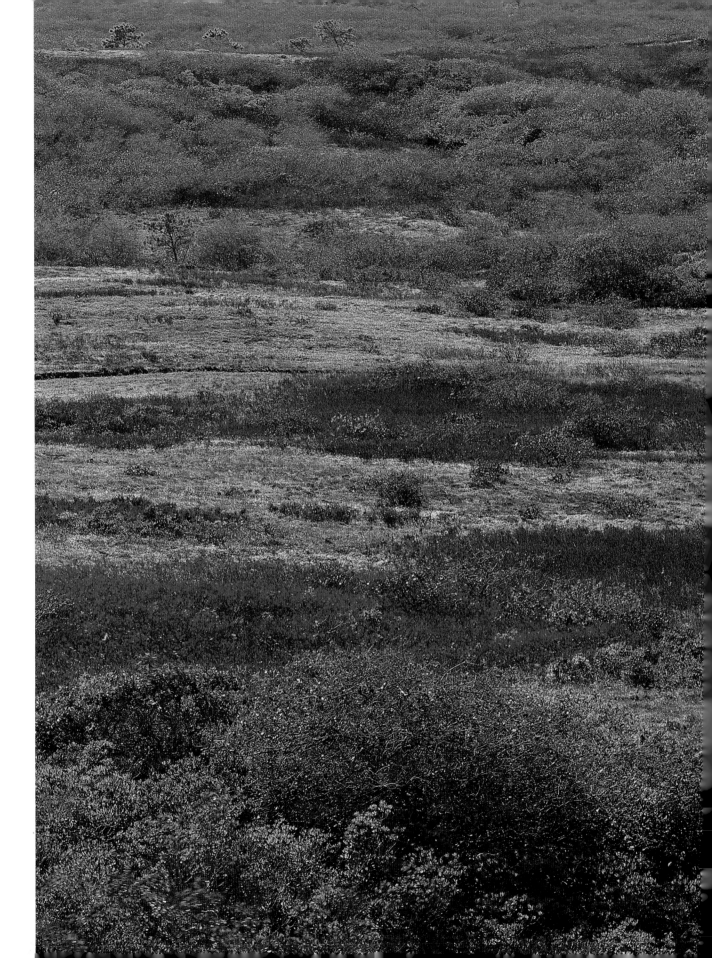

Some of the nation's largest moors, or heathlands, carpet Nantucket, home to about 1,000 deer, along with small mammals, piping plover, osprey, and an array of migrating birds.

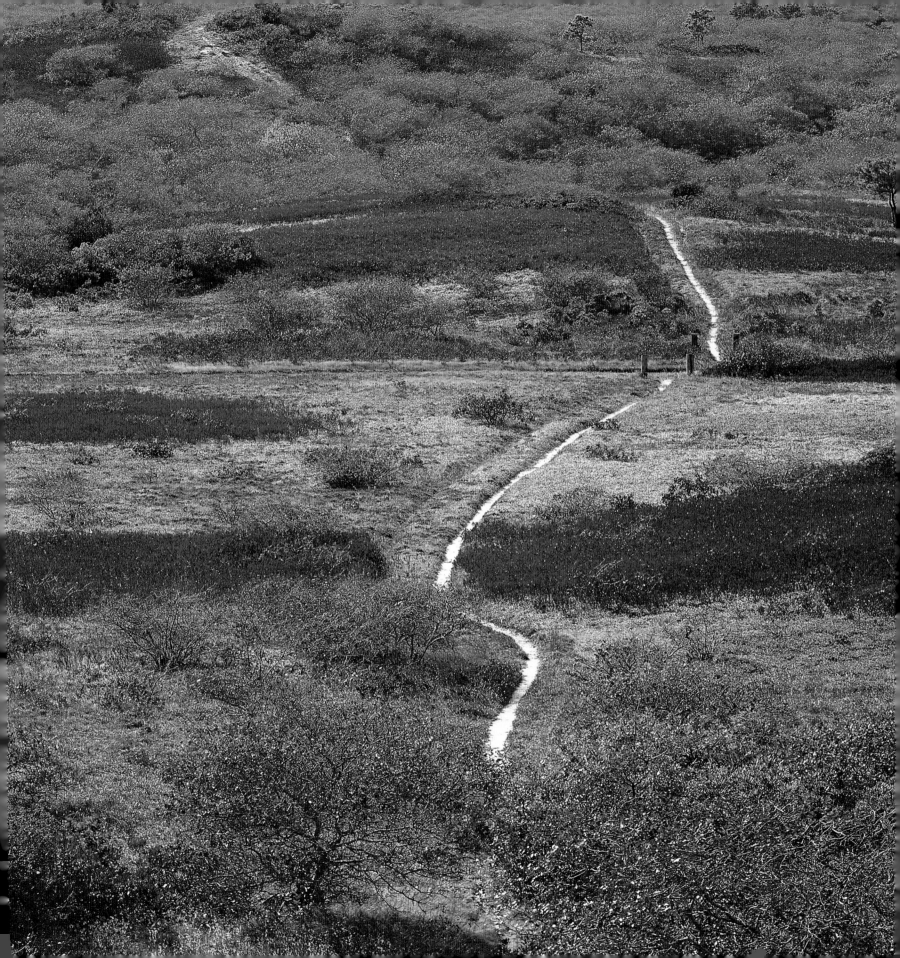

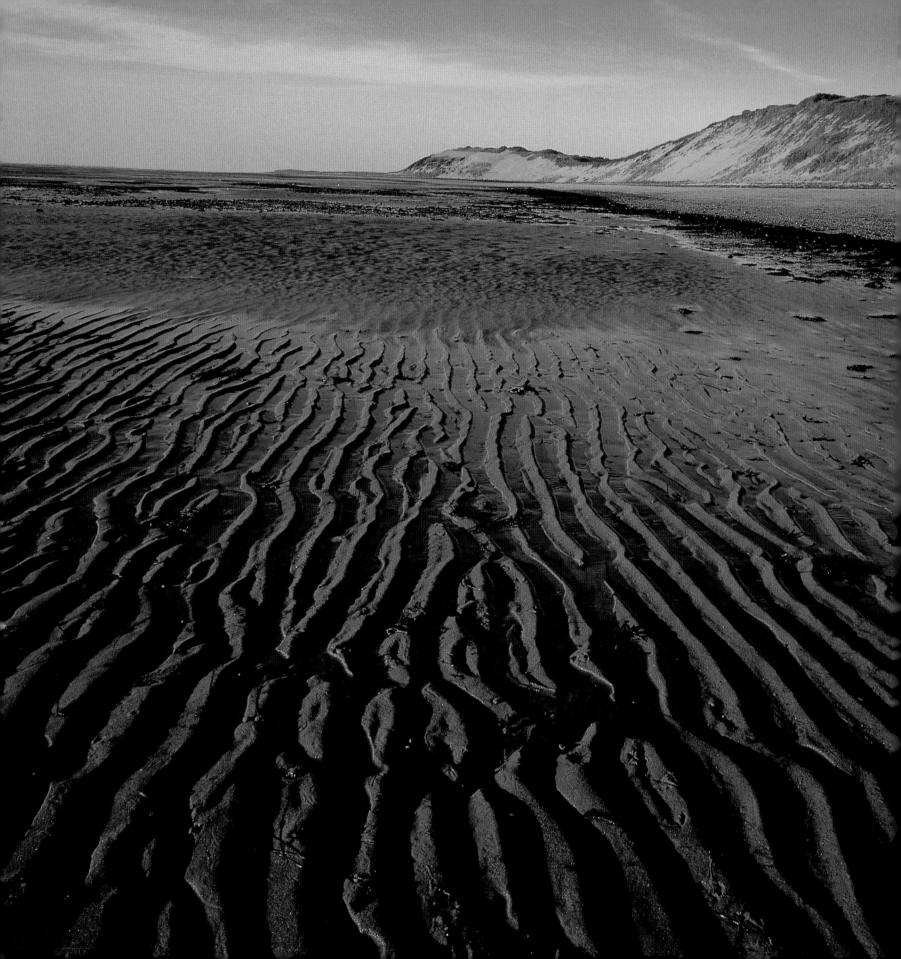

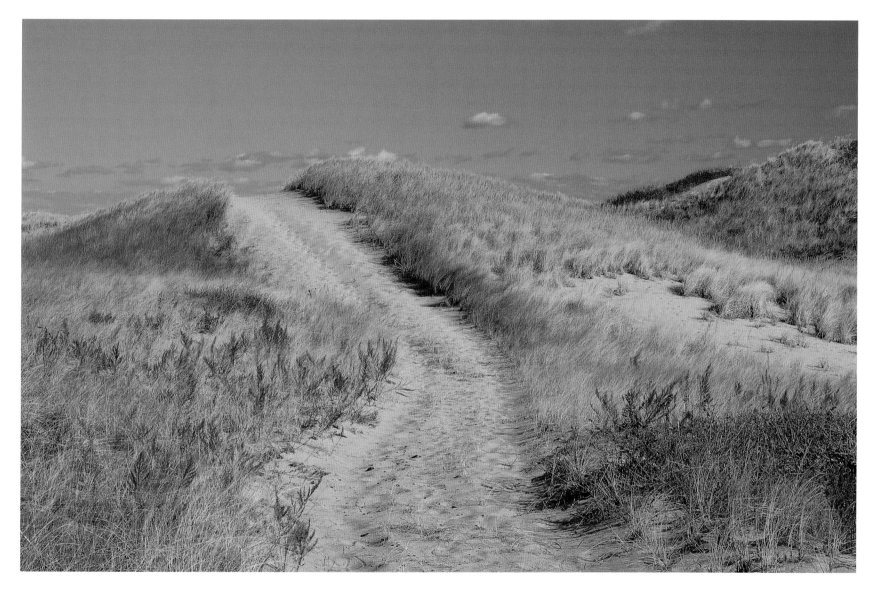

Designated in 1961, Cape Cod National Seashore protects the area's natural features – beaches, sand dunes, and forest stands – along with historic homes and lighthouses, still standing along the shores.

Constantly beaten by the waves, the islands off Cape Cod – known as kames, or knobs, by geologists – have been joined to the mainland by glacial debris and sand, separated, and joined again. Great Island is now connected to the mainland by a thin strip of sediment.

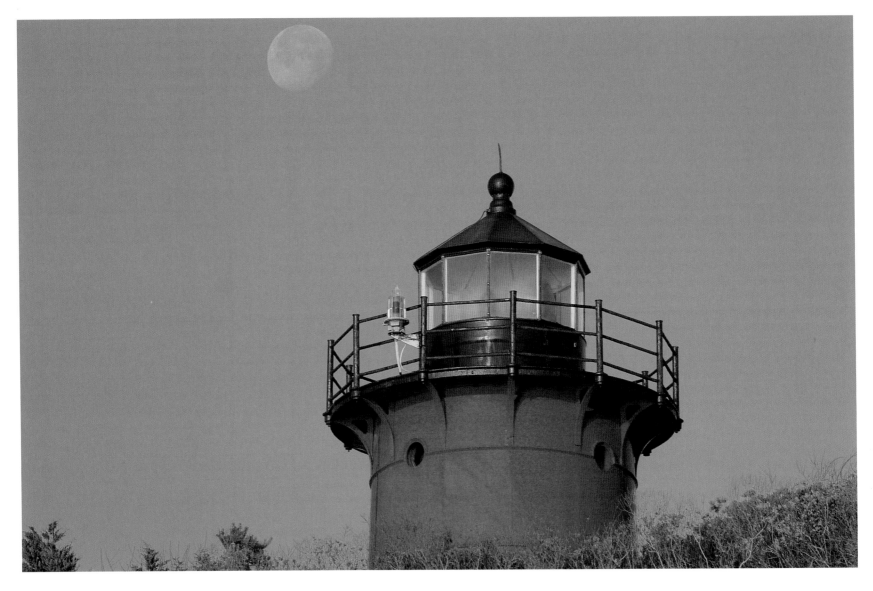

As storms battered the cliffs around Nauset Light, tearing away the soil until just 37 feet remained between the beacon and the precipice, local residents lobbied for the 1923 lighthouse to be saved. In 1996, it was moved 300 feet west, safely out of reach of the breakers.

Oaks and cedars flourish at the edges of salt water marshes within Cape Cod National Seashore. Occasionally, hikers come across a gnarled apple tree or a decaying dyke, reminders of the settlers who once lived here.

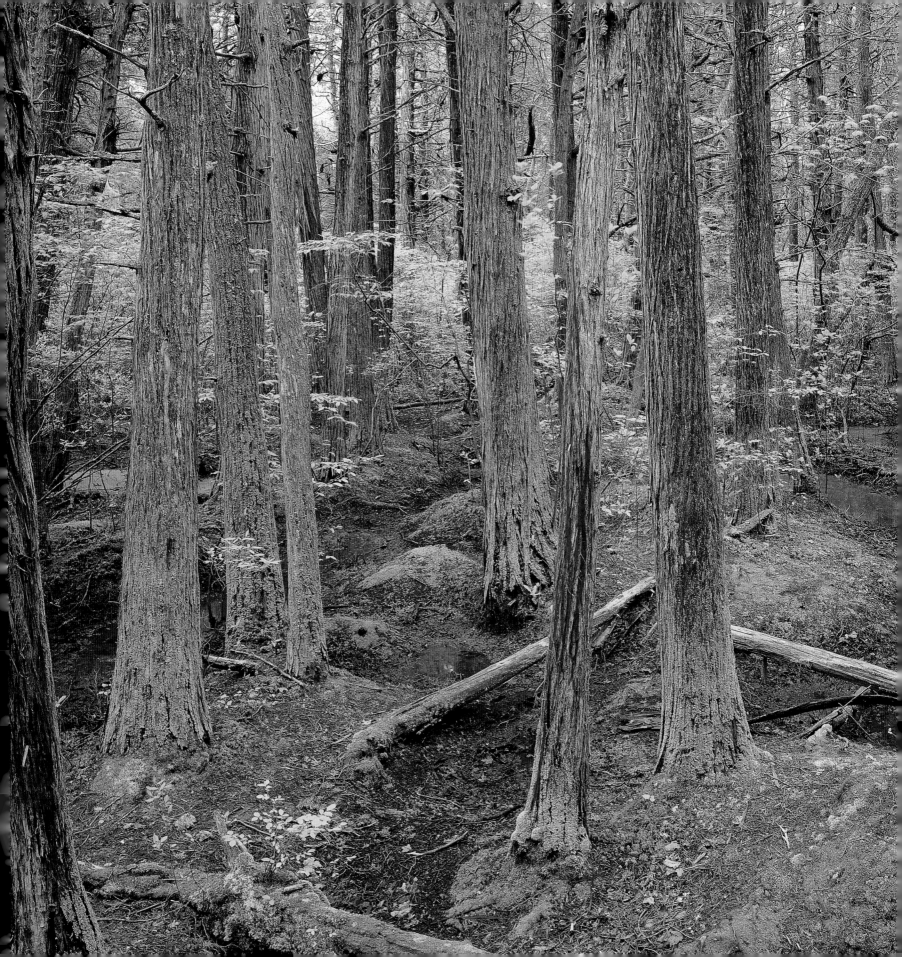

A former coast
guard station over-
looks Cape Cod
National Seashore.
Since the early
1800s, volunteers
working with the
Massachusetts
Humane Society
tried to help ship-
wreck survivors
along the coast. The
federal government
established the US
Life Saving Service
later in the century.

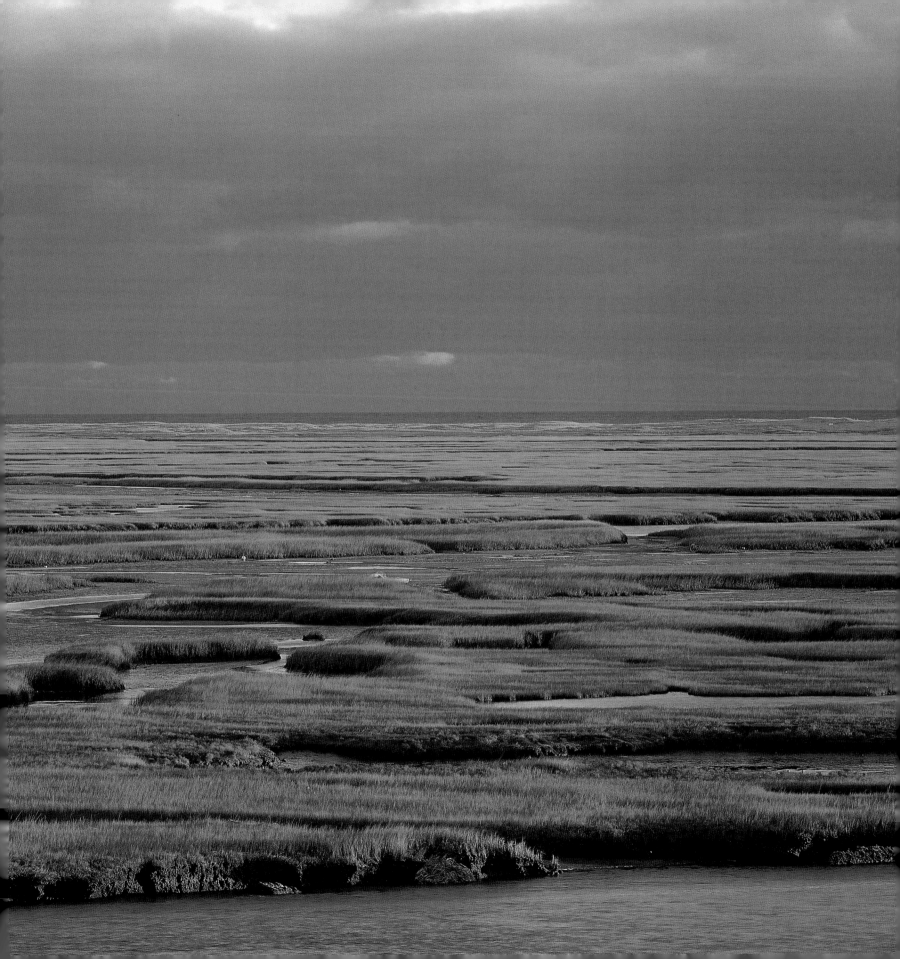

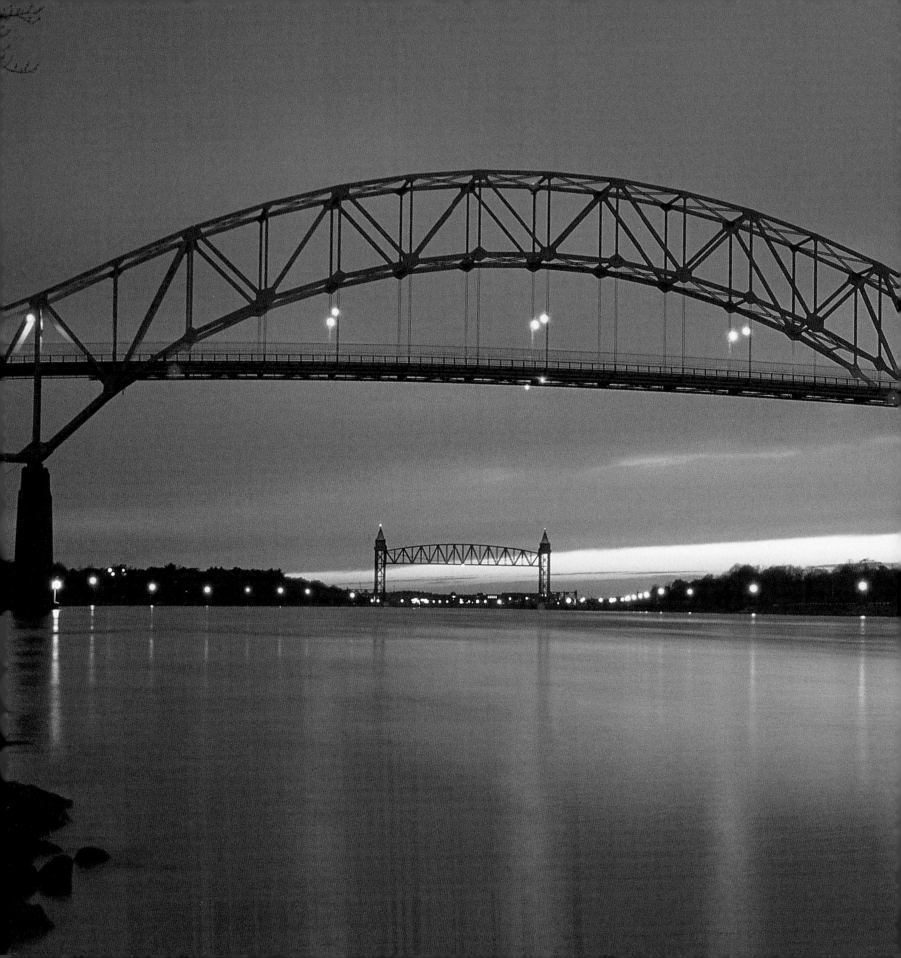

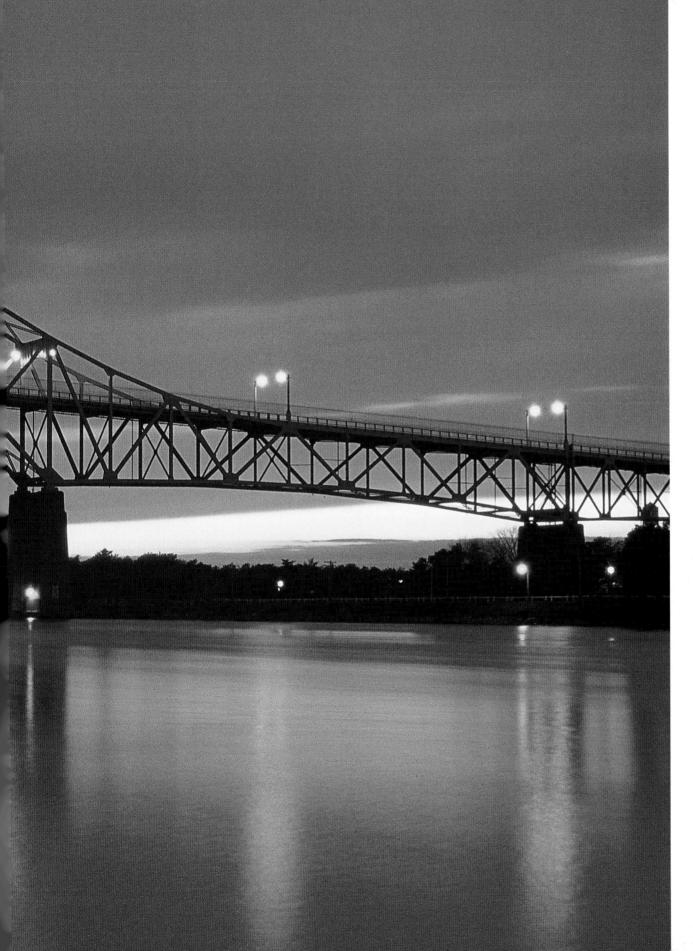

About 17 miles long, the Cape Cod Canal was built in 1914 to allow vessels to bypass the hazardous waters between Boston and the Cape. It remains the world's widest sea-level canal and is used by about 23,000 vessels each year.

23

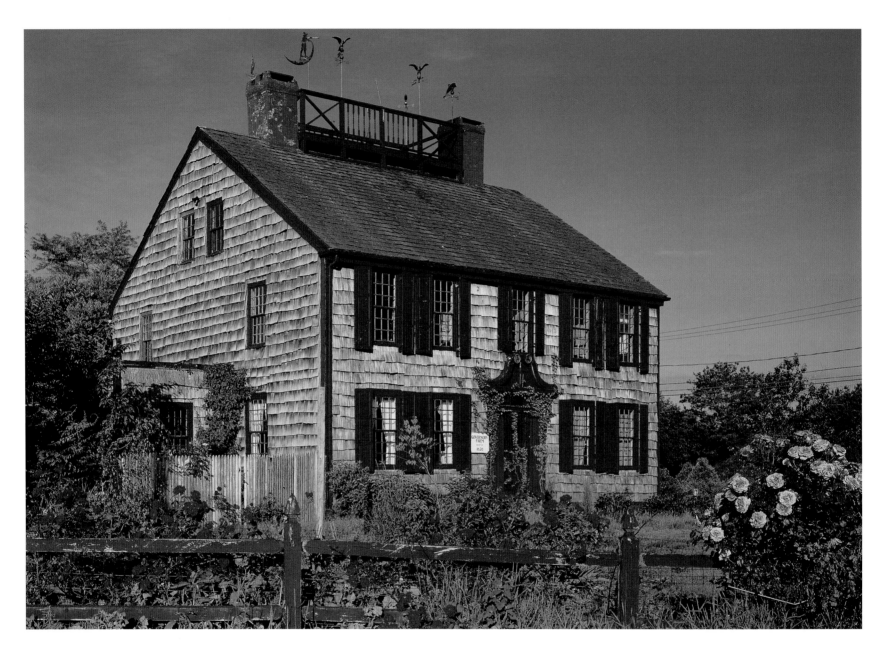

In the off-season Barnstable County is a serene collection of farms and fishing towns, home to 205,000 residents. By August, the population triples as vacationers pour in from around the world.

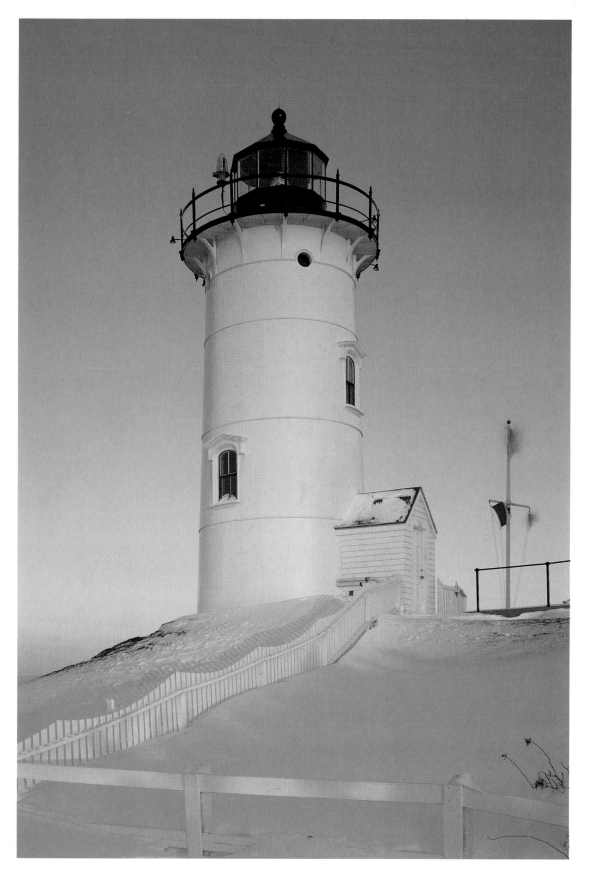

The bright white beacon of Nobska Light is visible to vessels 16 miles from shore, warning of underwater shoals and guiding ships into the Falmouth and Woods Hole harbors.

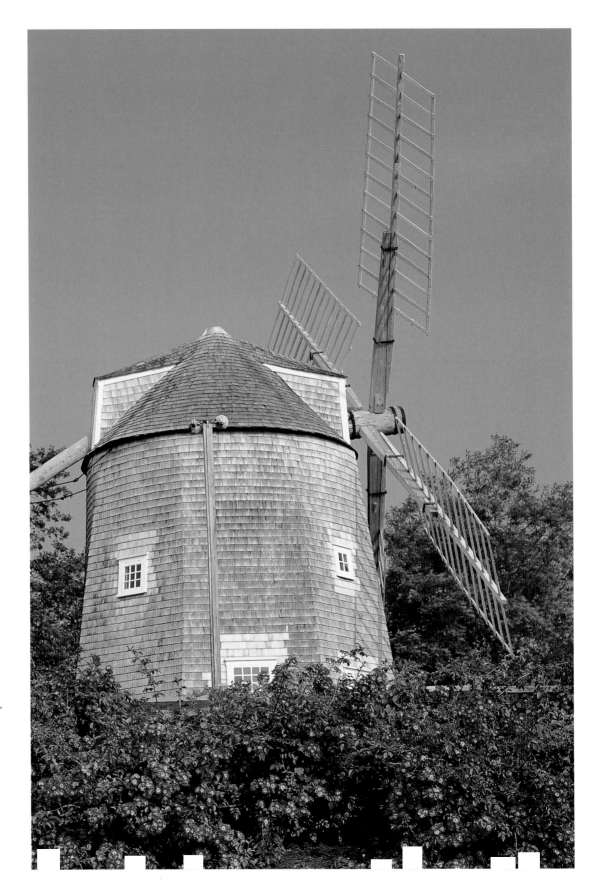

The Jonathan Young Windmill in South Orleans is a reminder of a time when salt production was a major industry on the Cape. Mills such as this one pumped ocean water into shallow vats to evaporate.

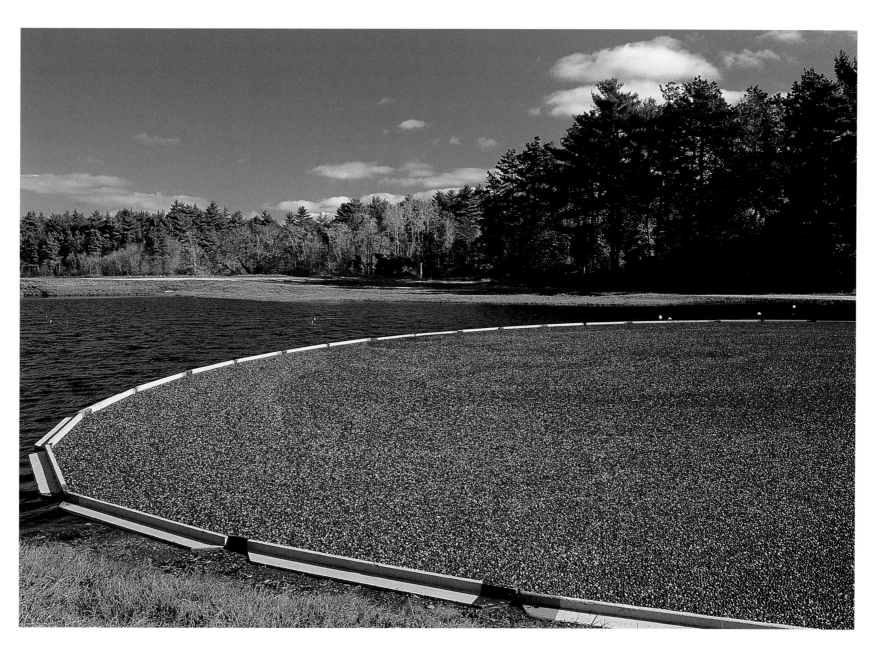

Cranberry growers in North Carver flood the bogs for the harvest season each year. Some of the plants in Massachusetts are 150 years old, and the state encompasses one-third of North America's cranberry cropland.

A popular harbor for pleasure boaters, Dartmouth is the fifth-largest town in Massachusetts. The town was founded by Quakers and other settlers seeking freedom from the strict laws of the Massachusetts Bay Colony in Plymouth.

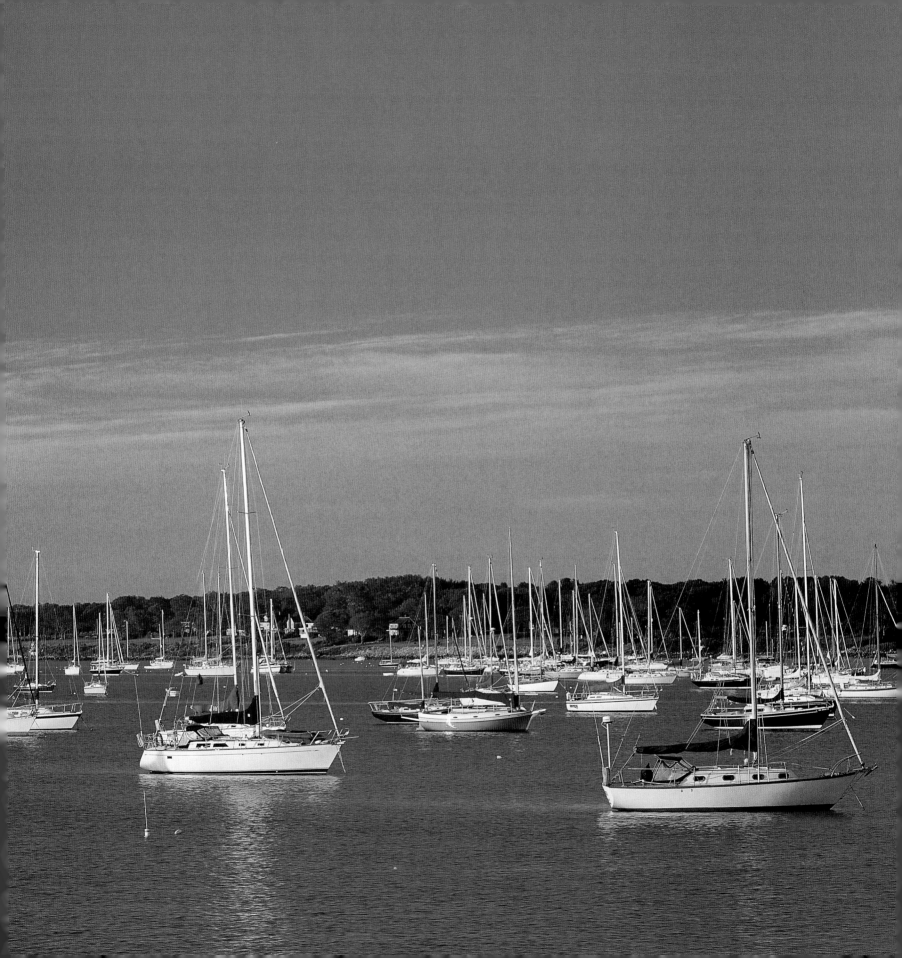

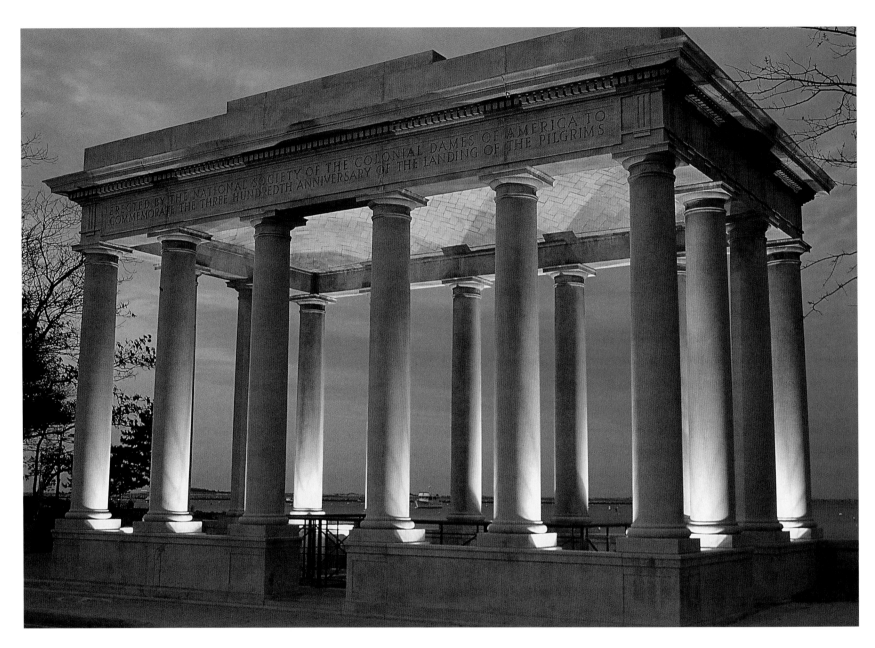

According to legend, the Pilgrims' first step in America was onto Plymouth Rock. The rock was later used as a symbol of independence by leaders of the American Revolution. Today, it is ensconced in a granite portico and inscribed with the date 1620.

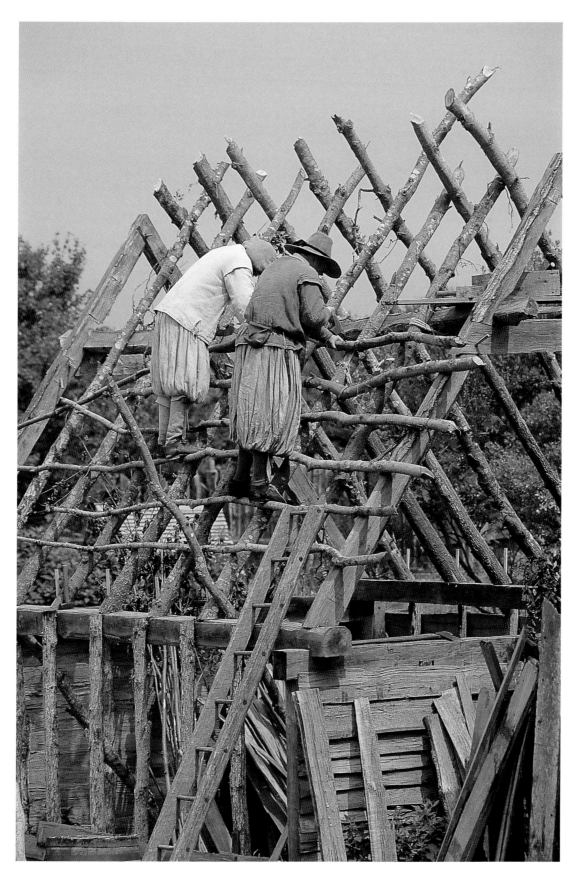

Plimouth Plantation sweeps visitors back in time to the seventeenth century, when the Pilgrims were forging the first colony in southern New England. Organizers have re-created a native hamlet nearby, also typical of the period.

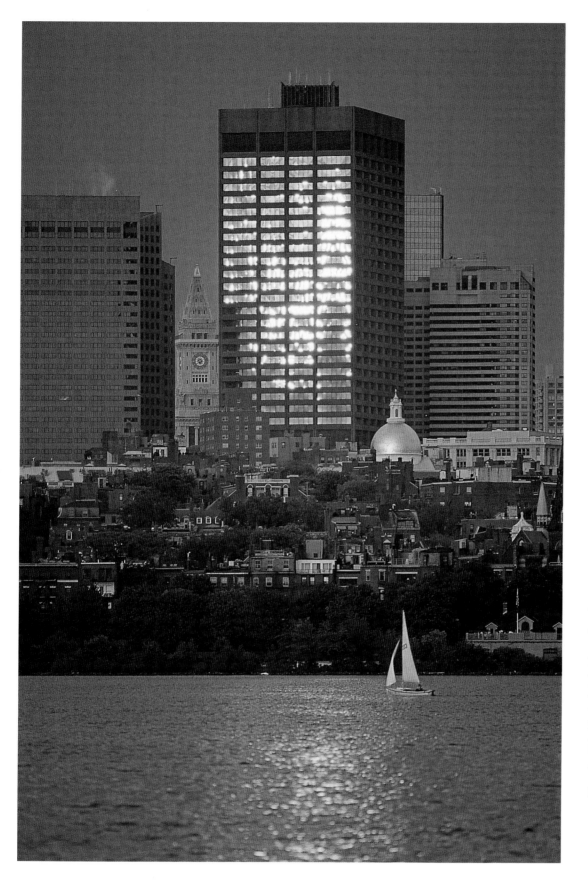

The Charles River is the center of outdoor recreation in Boston. In summer, sun-lovers bask along the banks while paddlers maneuver through the currents. On particularly snowy winter days, cross-country skiers take advantage of the riverside paths.

FACING PAGE—
Whale watching draws more and more visitors to Plymouth each summer. Humpback, finback, minke, right, and pilot whales breach off the coast, within a two-hour boat ride from shore.

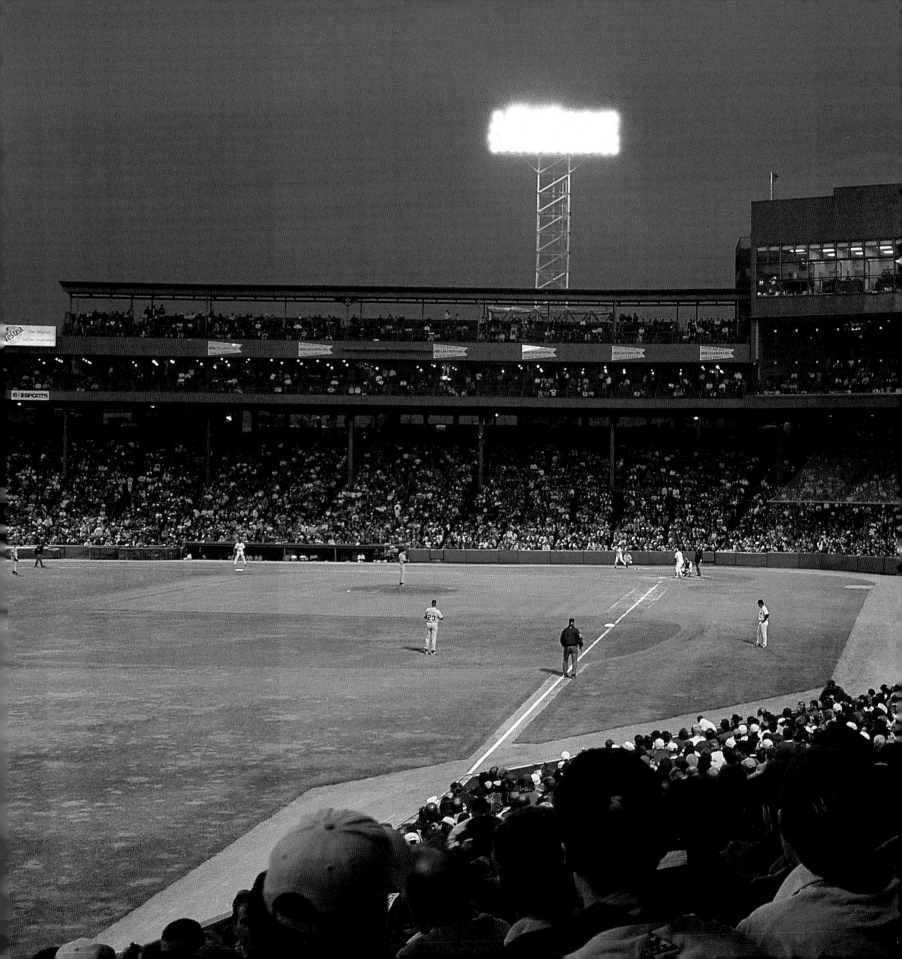

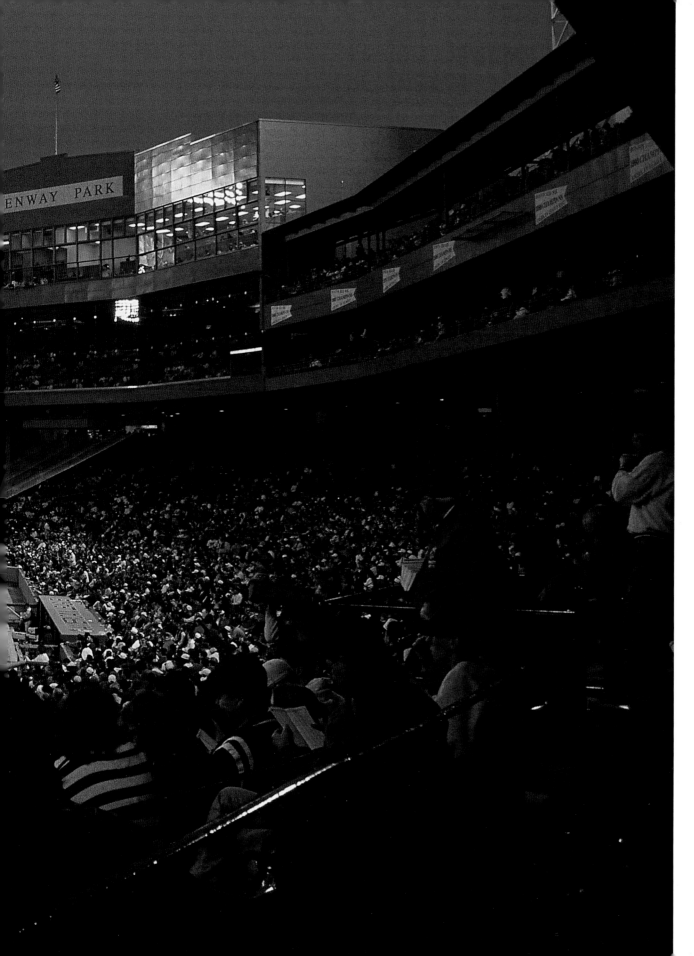

Fenway Park has become one of baseball's most famous stadiums since "the Green Monster" opened in 1912. In the first game played here, the Red Sox overcame the New York Highlanders – later renamed the Yankees – by 7-6.

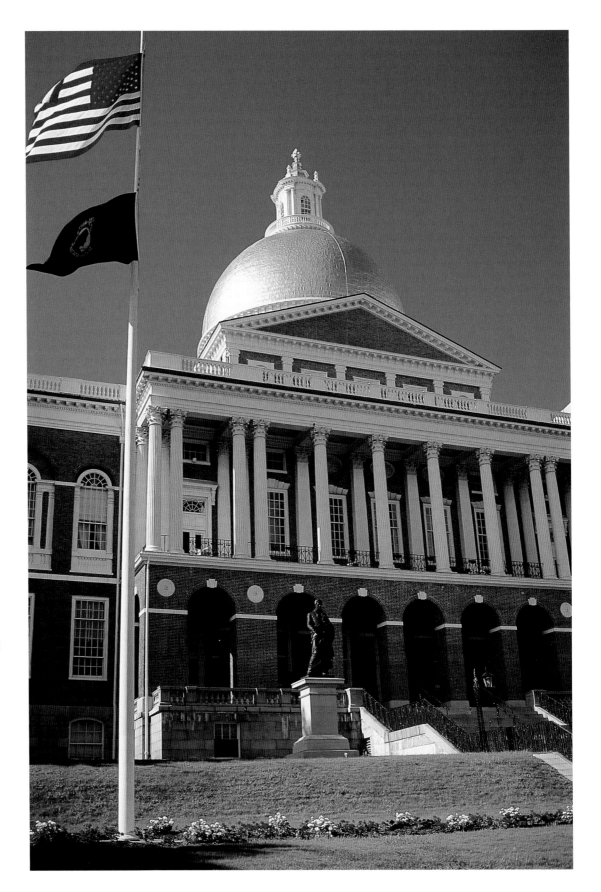

The State House in Boston has witnessed major historical events over the centuries. Among them was the 1773 Boston Tea Party, when American colonists boarded British ships and dumped more than 300 chests of tea overboard to protest taxation without representation.

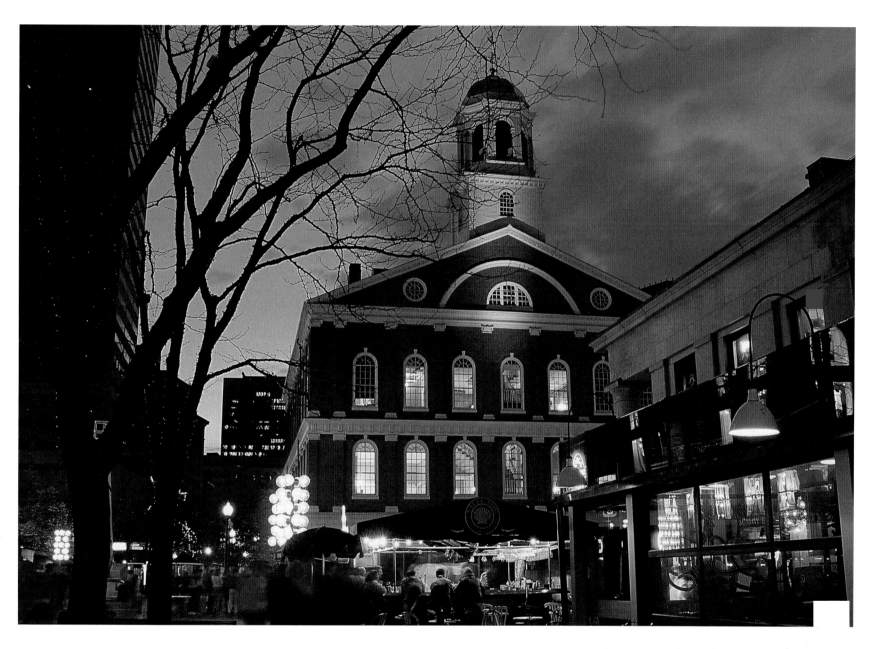

Faneuil Hall and Quincy Market, with their colorful push carts, restaurants, galleries, and retail stores, are favorite shopping destinations for Boston's visitors and residents. George Washington proposed a toast to a new nation from Faneuil Hall on America's first birthday.

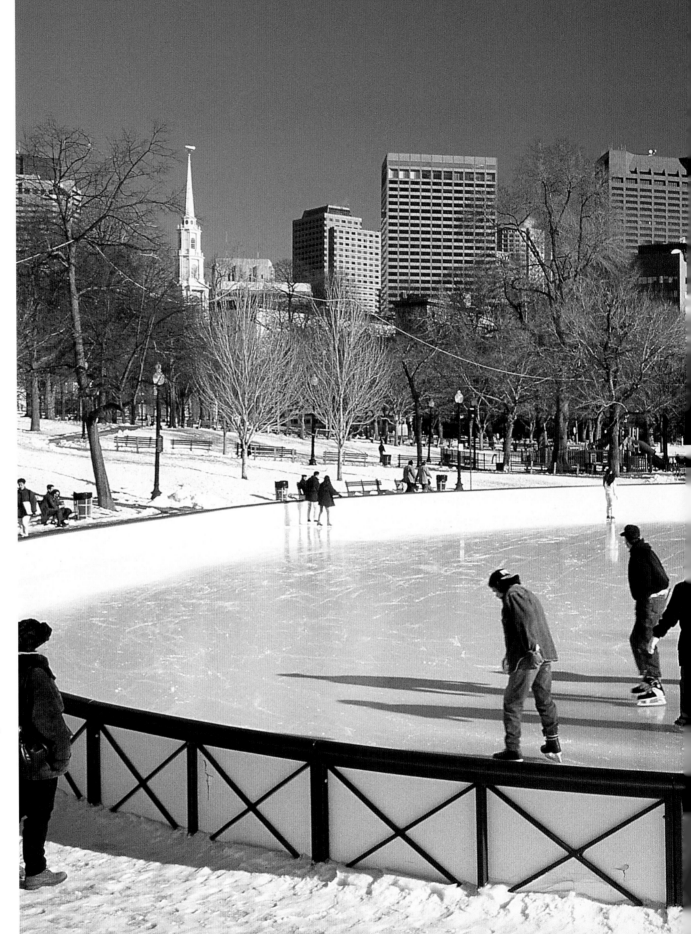

The city of Boston takes pride in its 215 parks and playgrounds, totalling more than 2,000 acres of public land. Bustling squares and wooded walking trails, concert venues and sports fields allow for a wide range of outdoor activities.

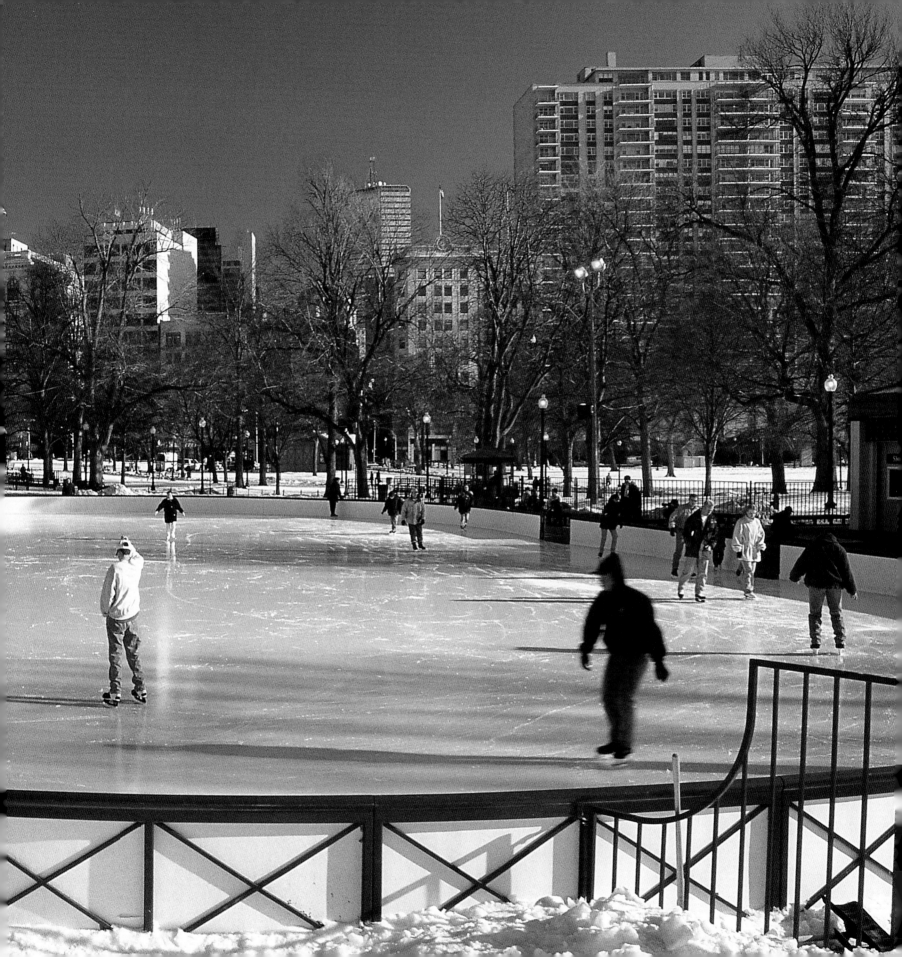

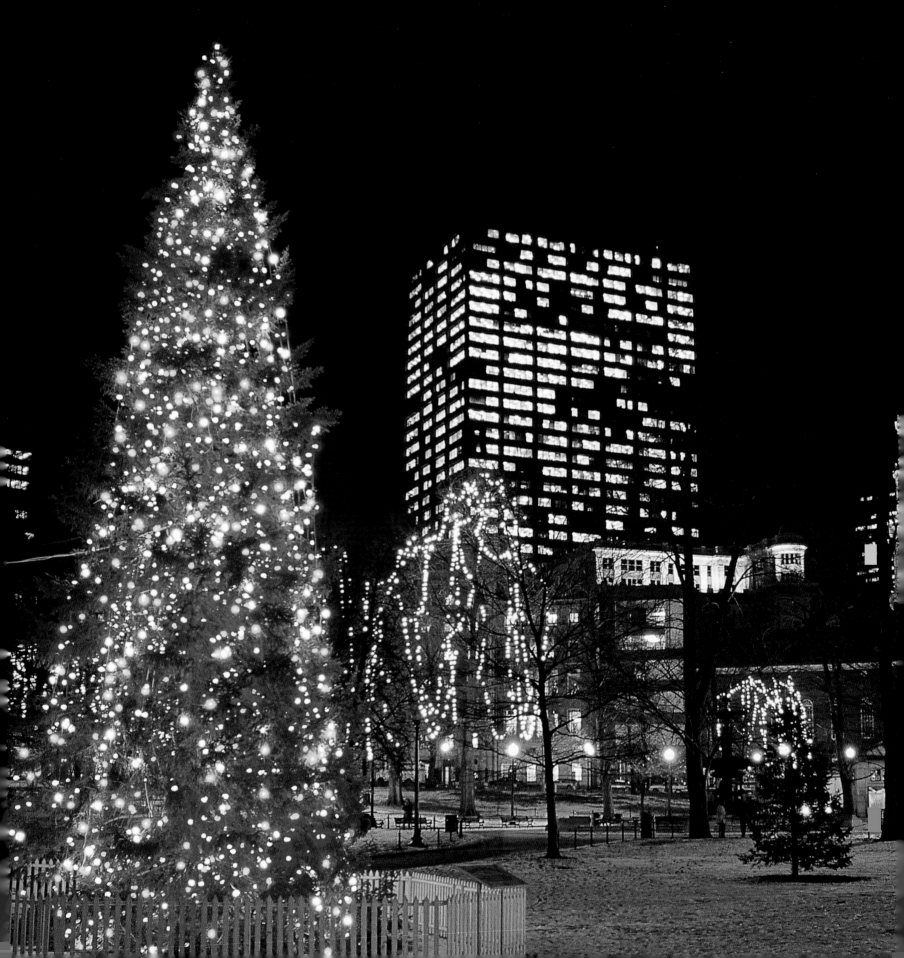

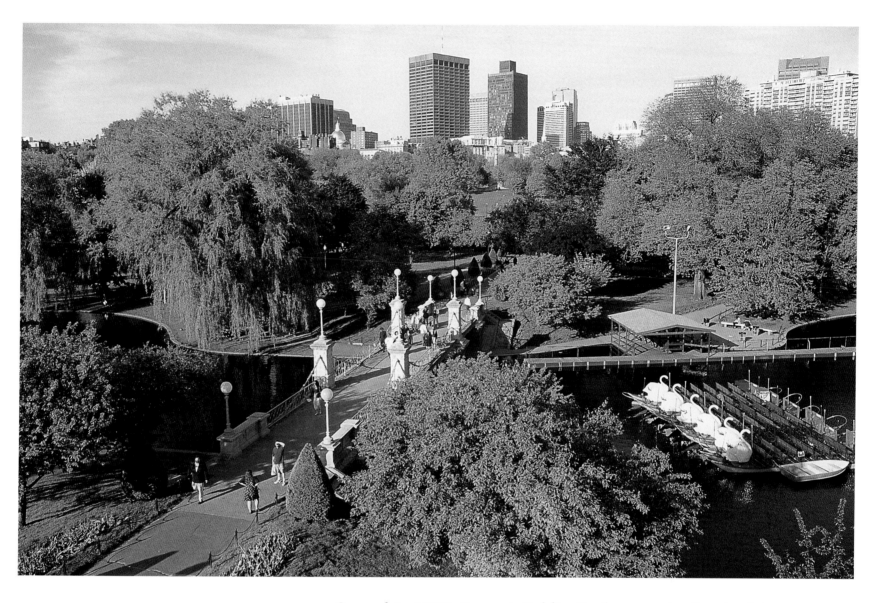

Created in 1837, Boston's Public Garden was the first in the nation. Visitors can wander the paths past blooms from around the world or tour the lagoon on a pedal-powered swan boat, a city favorite since 1877.

Boston Common was first set aside in 1634 as cattle-grazing land for the livestock of the settlers. The 50-acre green later served as a central site for public meetings and speeches, along with the occasional hanging.

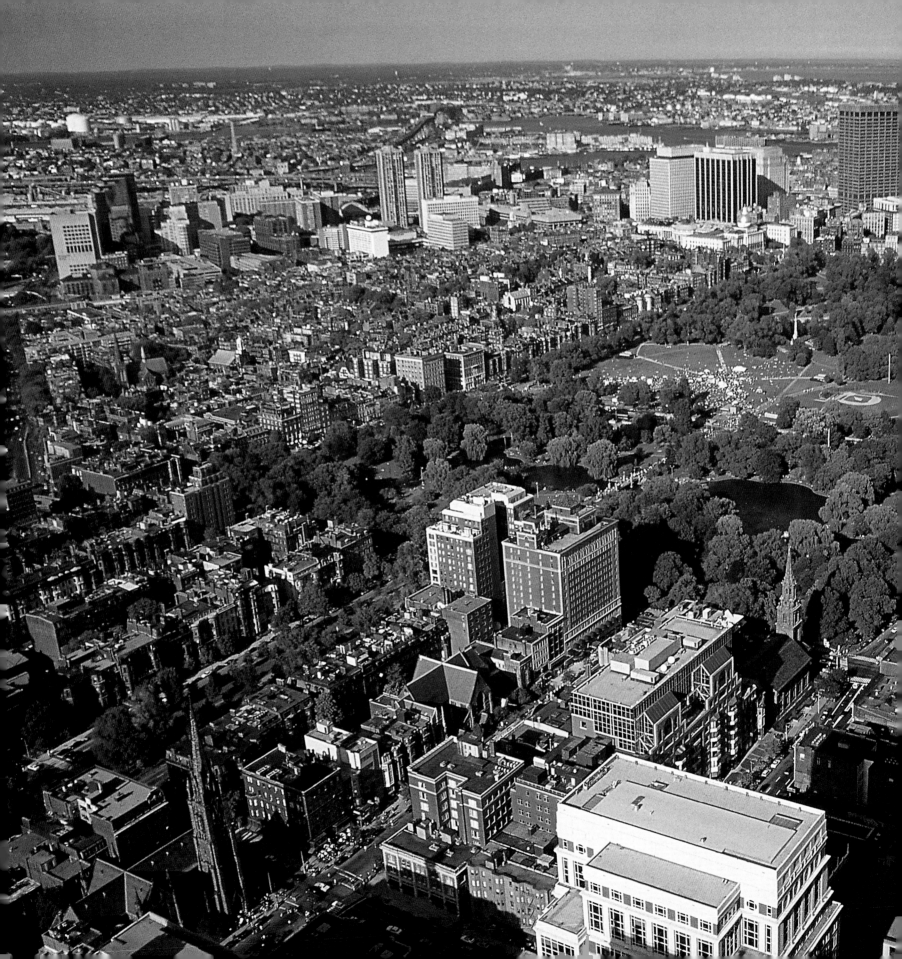

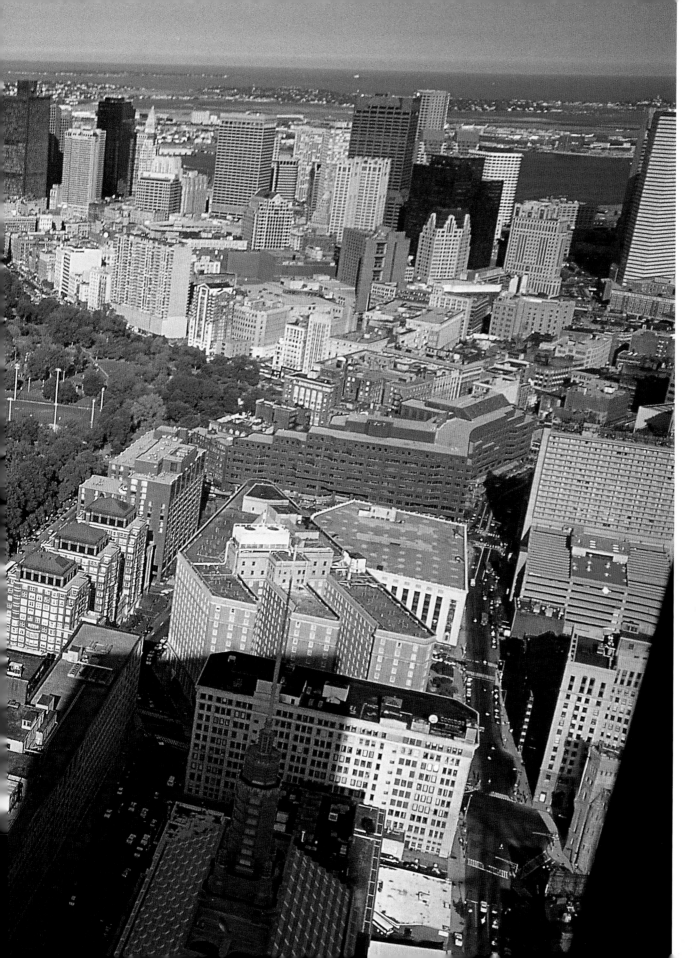

From the 740-foot John Hancock Observatory, New England's tallest building, visitors gain a panoramic view of the city. Many sight-seers choose to walk the Freedom Trail through Boston, a 2½-mile route past 14 historic sites.

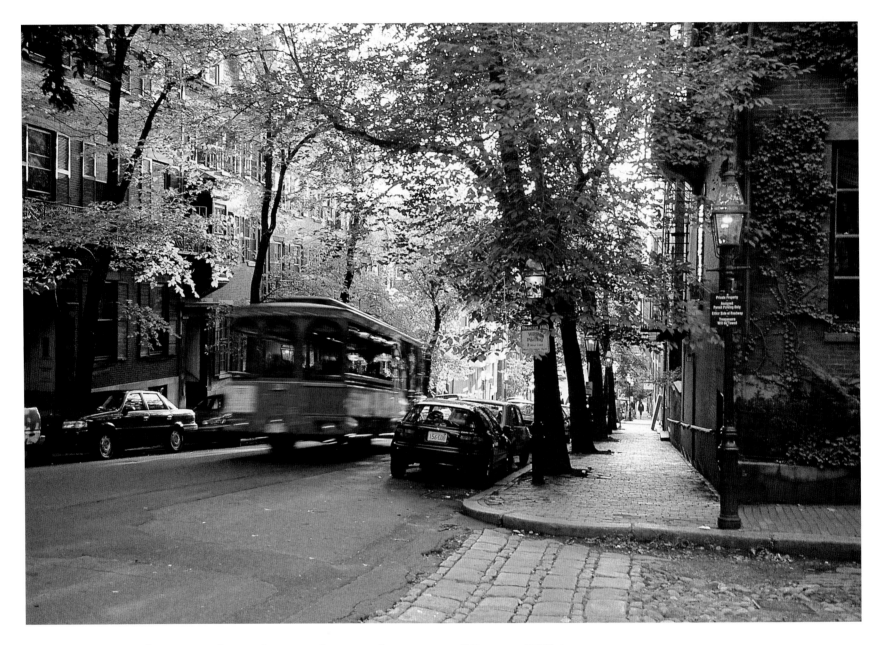

When the city of Boston planned to modernize the streets of Beacon Hill in the 1940s, local women staged a sit-in, successfully demanding that the historic brick sidewalks and cobblestone streets be preserved.

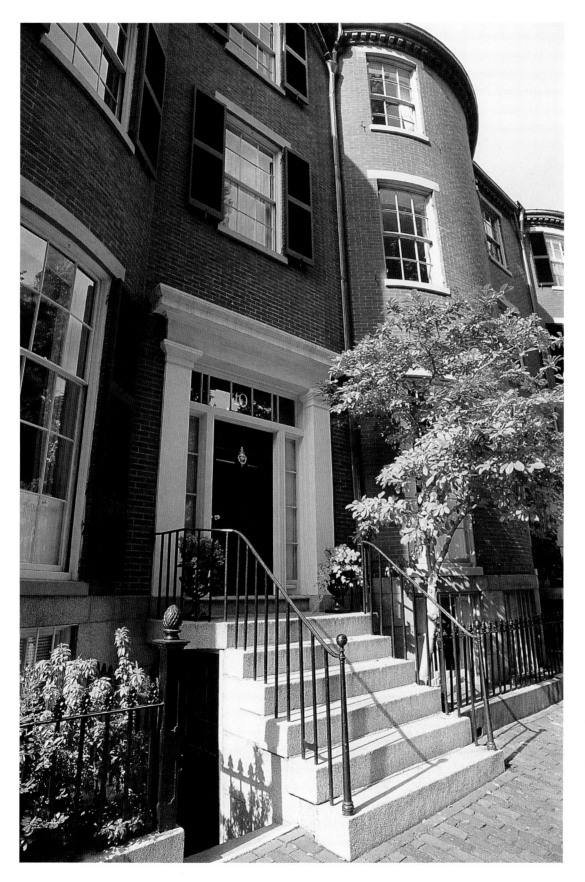

Author Louisa May Alcott spent part of her childhood in this house in Boston's Beacon Hill area. When she wrote *Little Women* in 1868, she was living in Orchard House in nearby Concord, Massachusetts.

In 1775, Paul Revere rode from Boston to Lexington, warning of an impending British attack. His journey was immortalized in Henry Wadsworth Longfellow's poem "Paul Revere's Ride". Today, visitors can take a self-guided tour of the silversmith's home.

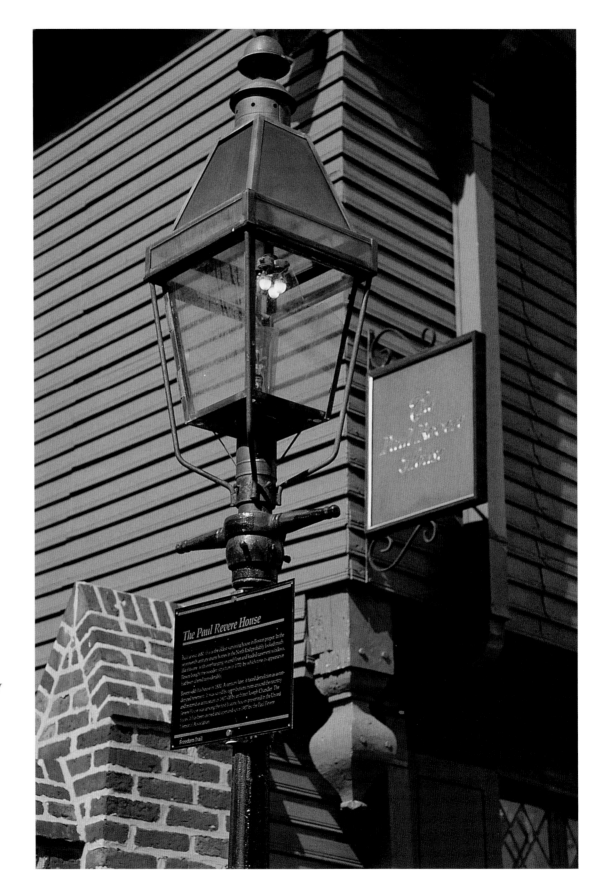

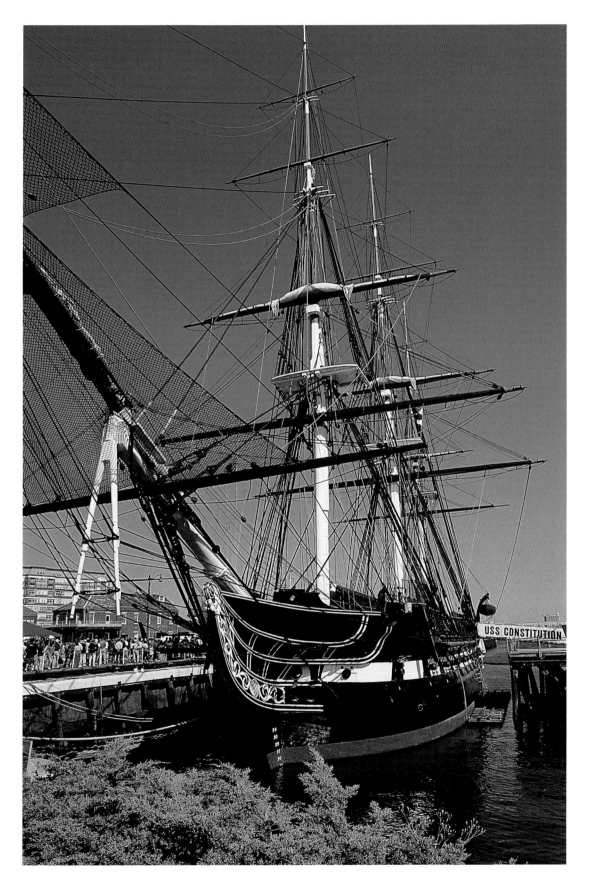

The world's oldest commissioned warship that is still afloat, the USS *Constitution* is on display at the Charlestown Navy Yard. For more than 150 years, from 1800 to 1974, the yard produced some of the nation's most advanced vessels.

America's first university, Harvard was founded in 1636 with nine students and a single instructor. Today, more than 18,000 students are enrolled and alumni include six U.S. presidents.

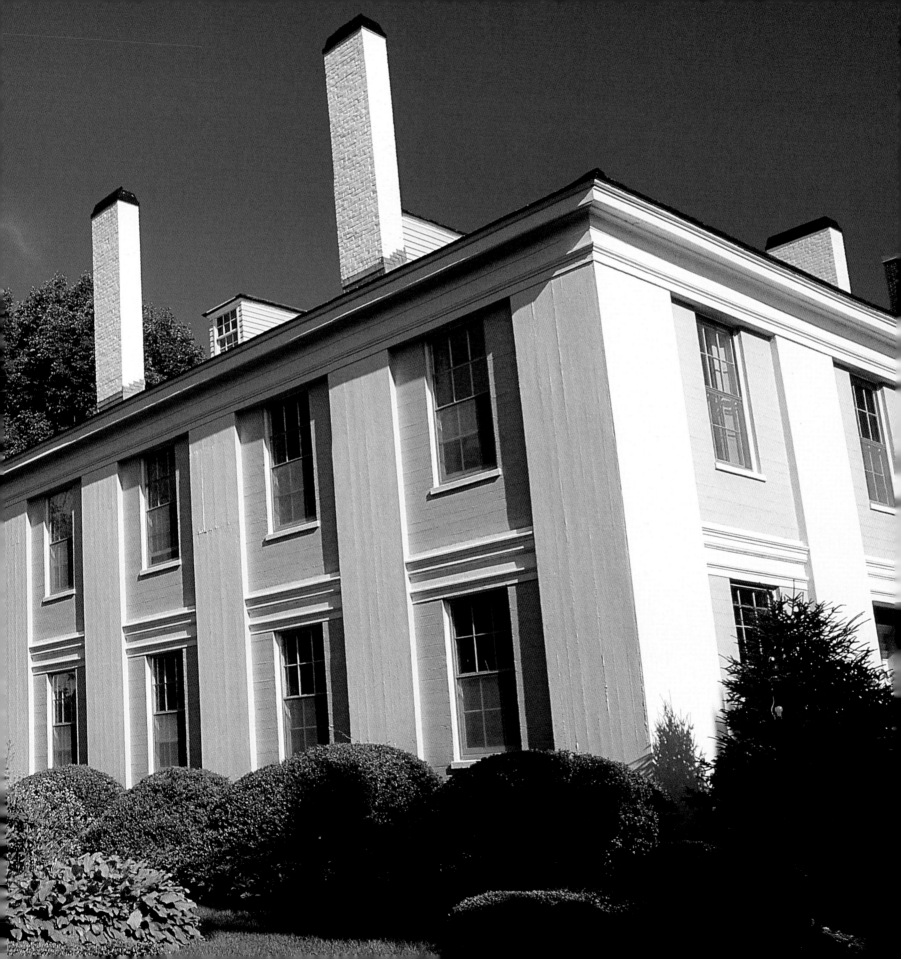

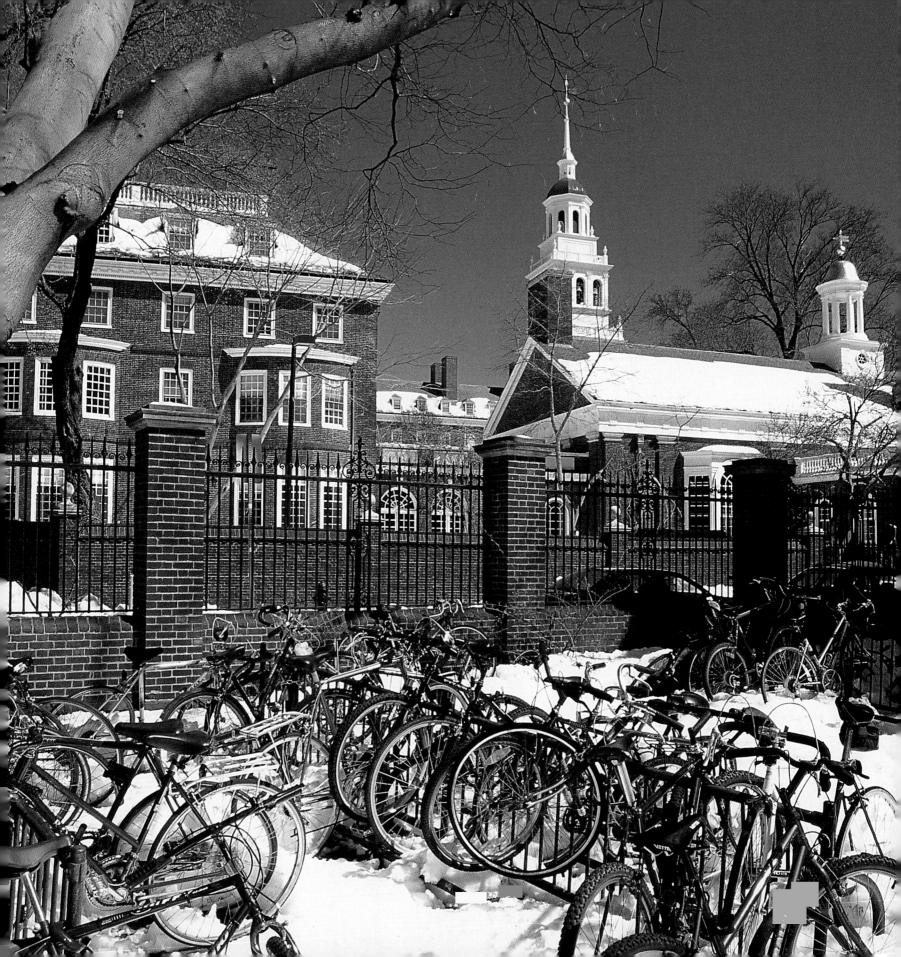

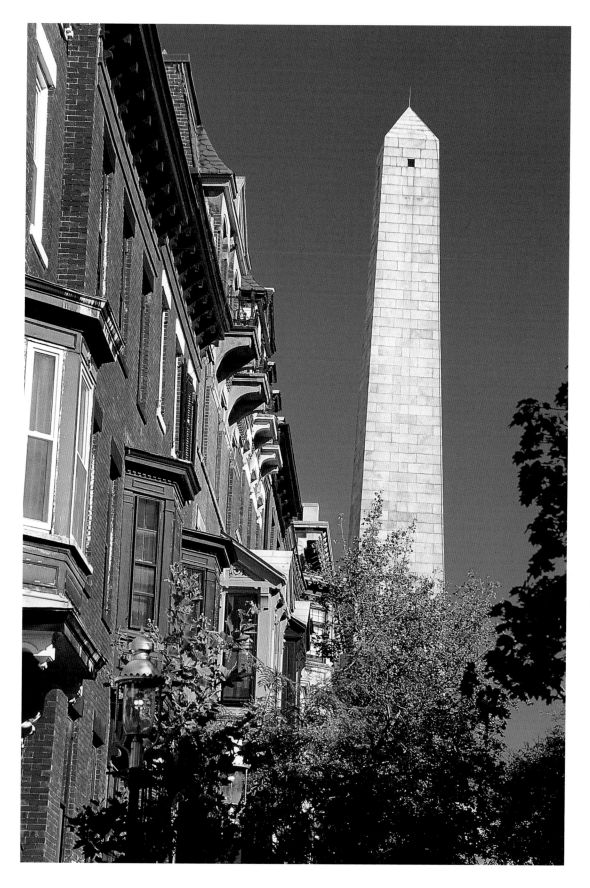

The 221-foot Bunker Hill Monument, visible here behind the nineteenth-century homes of Monument Avenue, actually stands atop Breed's Hill. The revolutionary troops who spent the night building fortifications on June 16th, 1775, had confused the hilltops.

FACING PAGE—
Just across the Charles River from Boston, Cambridge is a lively collection of students and professionals. Along with Harvard University and the Massachusetts Institute of Technology, many high-tech companies are based in the city.

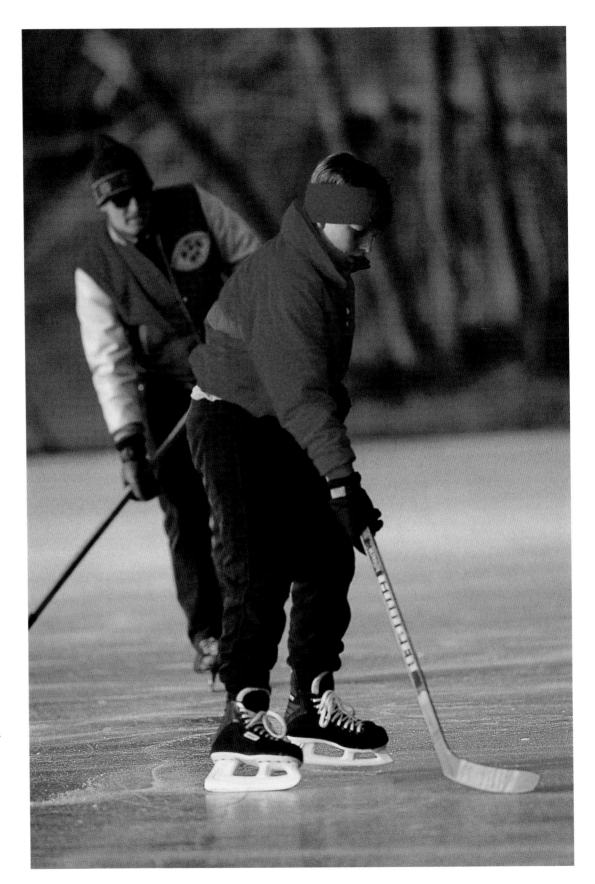

Local hockey enthusiasts take advantage of a chilly winter day near Cambridge. On average, midwinter temperatures in the city range from 36° to 22°F.

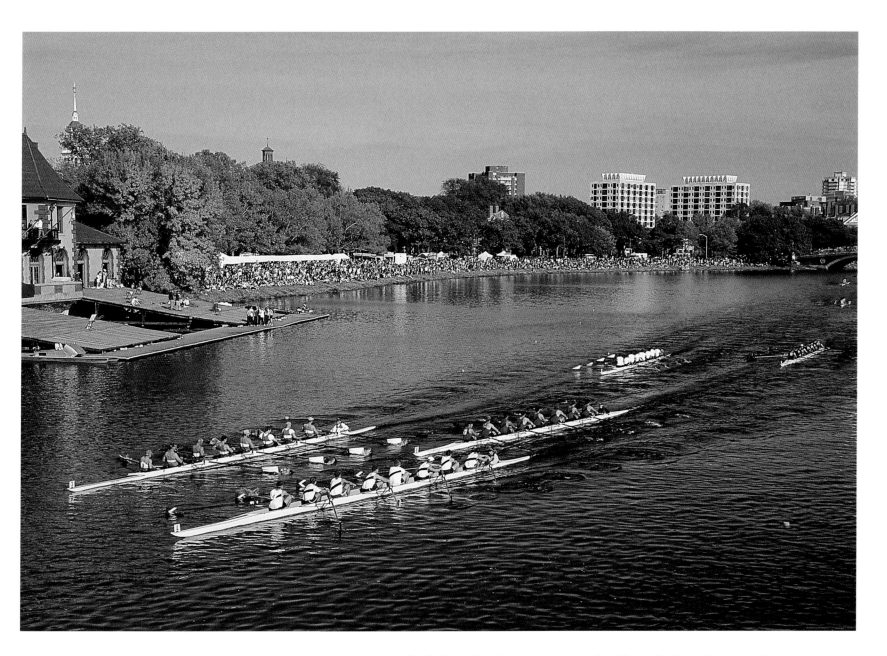

The Head of the Charles Regatta is held each October in Cambridge on the Charles River. The largest two-day rowing event in the world, it draws 5,500 participants. Winners claim the title "Head of the Charles."

Provincetown's population grows to 10 times its usual size during the hot summer months when city dwellers flock to the oceanside cottages and expansive, white sand beaches. Many of the historic homes and commercial buildings here are protected from development.

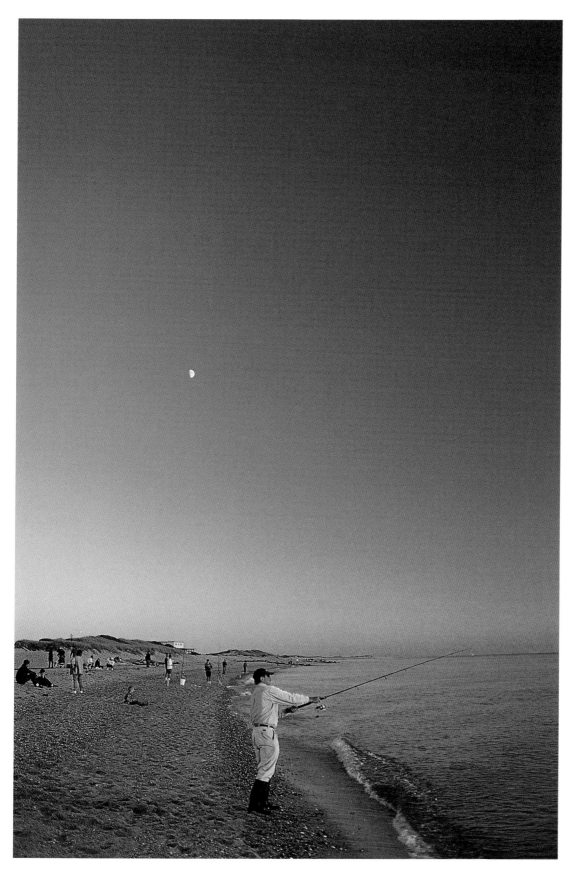

Provincetown boasts the largest natural harbor on the coast, a fact that made it a mecca for nineteenth-century whaling ships. By the mid-1800s, it was one of the busiest ports in the nation.

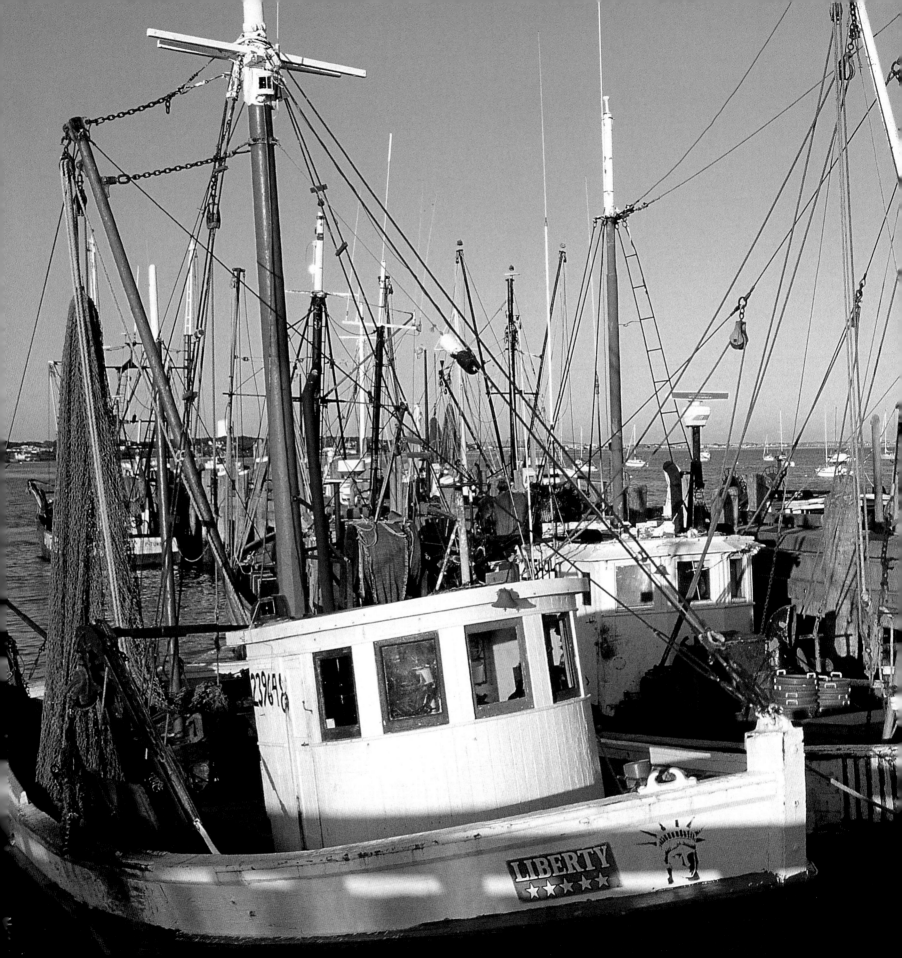

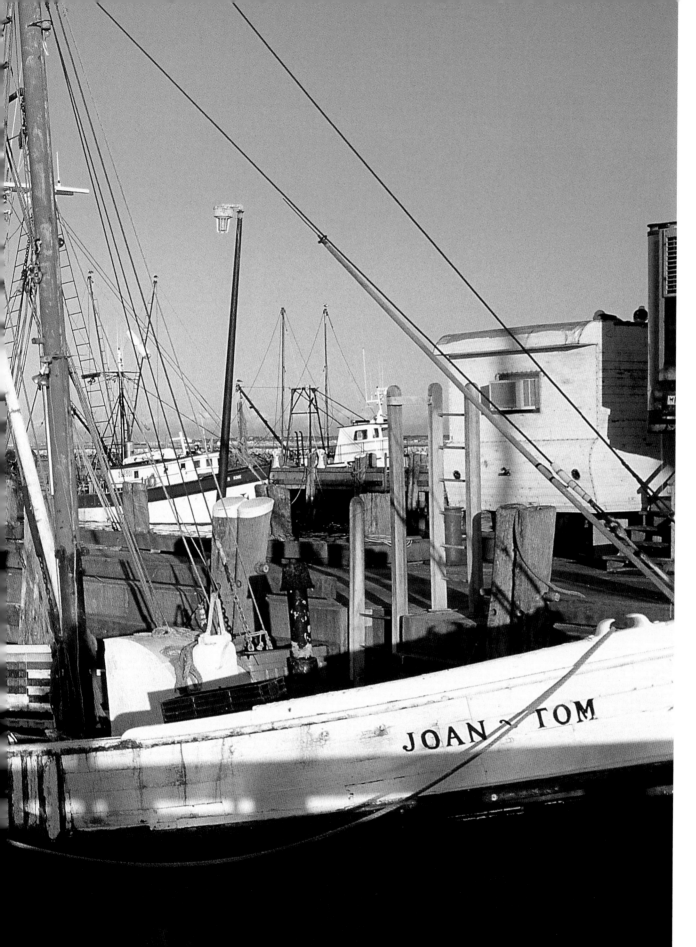

The Pilgrims may have settled in Plymouth, but they first dropped anchor in Provincetown, where they stopped long enough to draft *The Mayflower Compact*, a document outlining how the new colony would govern itself.

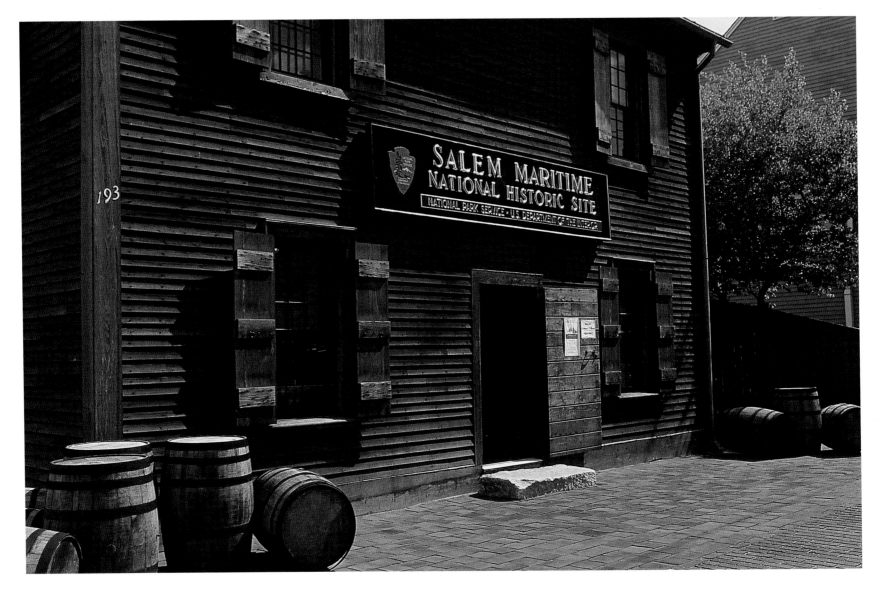

The Salem Maritime National Historic Site offers a glimpse of a time
when goods were plentiful from the West Indies – rich molasses,
sugar cane, and sweet tropical fruits.

Salem's Witch Museum explores the witchcraft trials of 1692. Based
on the testimony of young girls who claimed to be haunted by their
neighbors' invisible shapes, 19 people were sentenced to death.
The executions stopped when spectral evidence was banned from
the court.

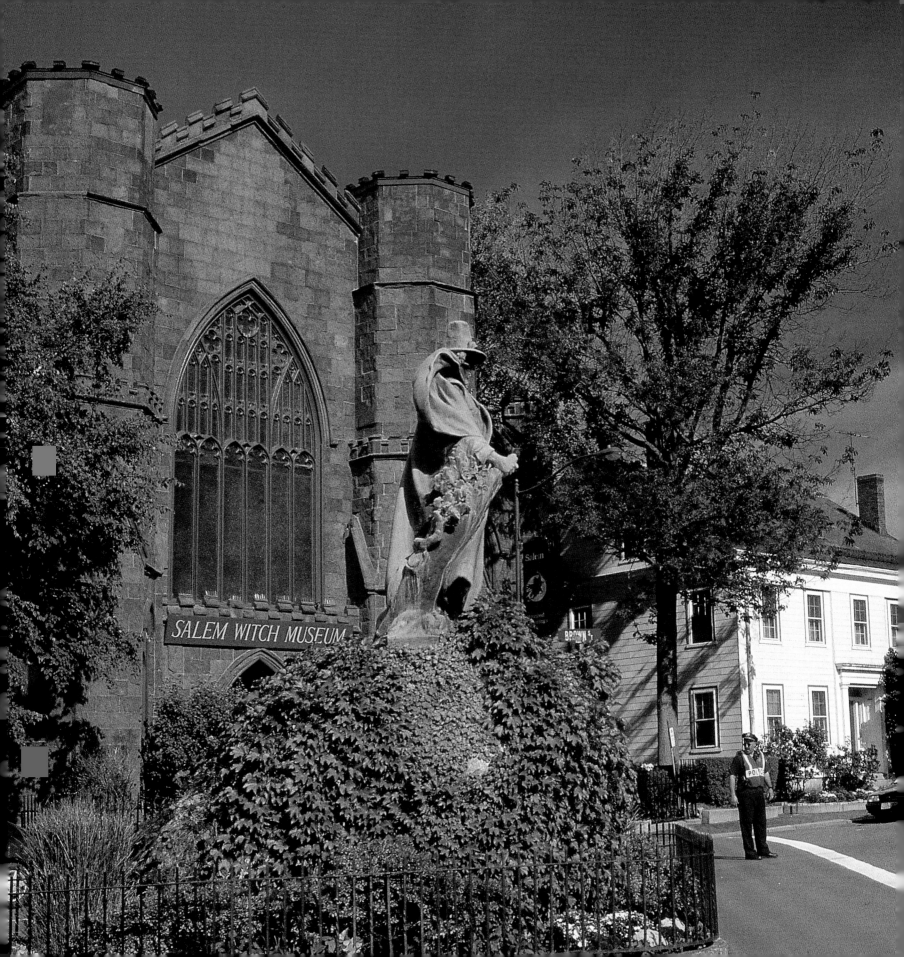

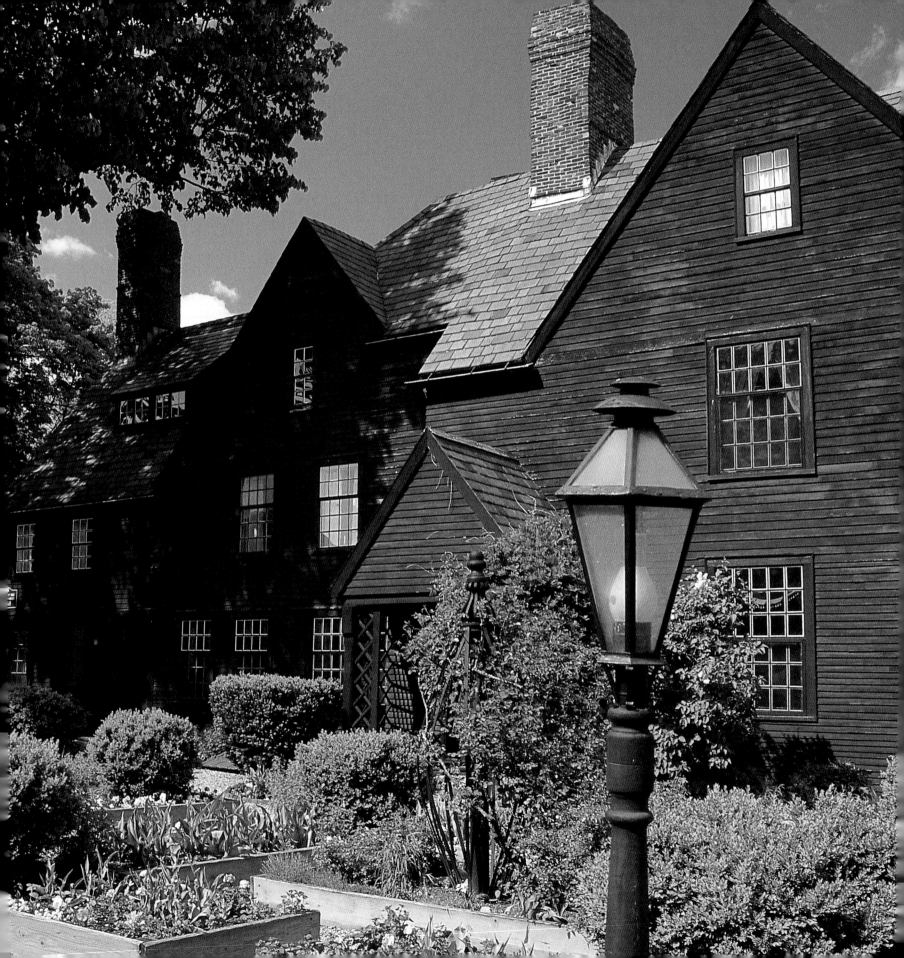

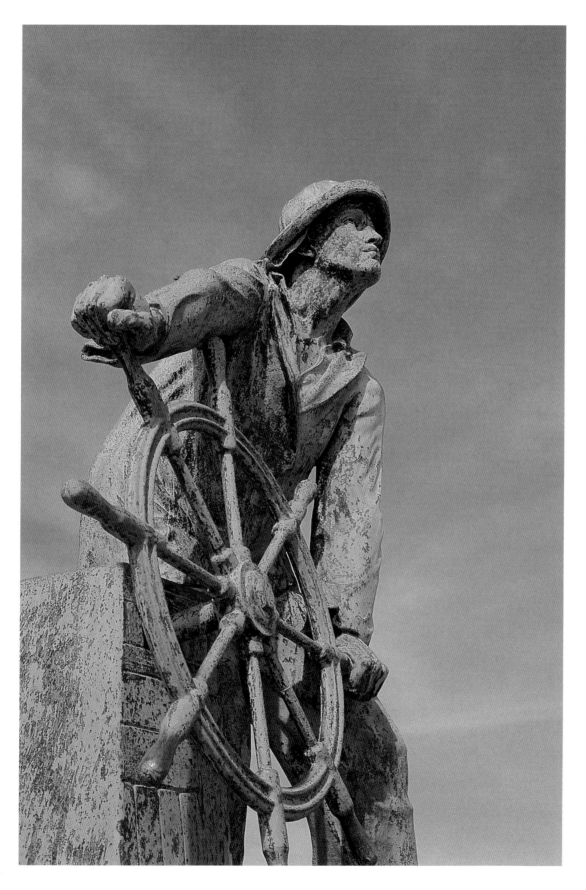

The Gloucester Fisherman,
known locally as the Man
at the Wheel, watches
over the oldest seaport
in America, and one of
the busiest on the coast.
Gloucester recently gained
international fame with the
release of the book and
movie *The Perfect Storm.*

FACING PAGE—
Built in 1668, this Salem
home inspired author
Nathaniel Hawthorne to
write *The House of Seven
Gables.* A national historic
district now protects the
building, along with five
nearby examples of seven-
teenth-century architecture.

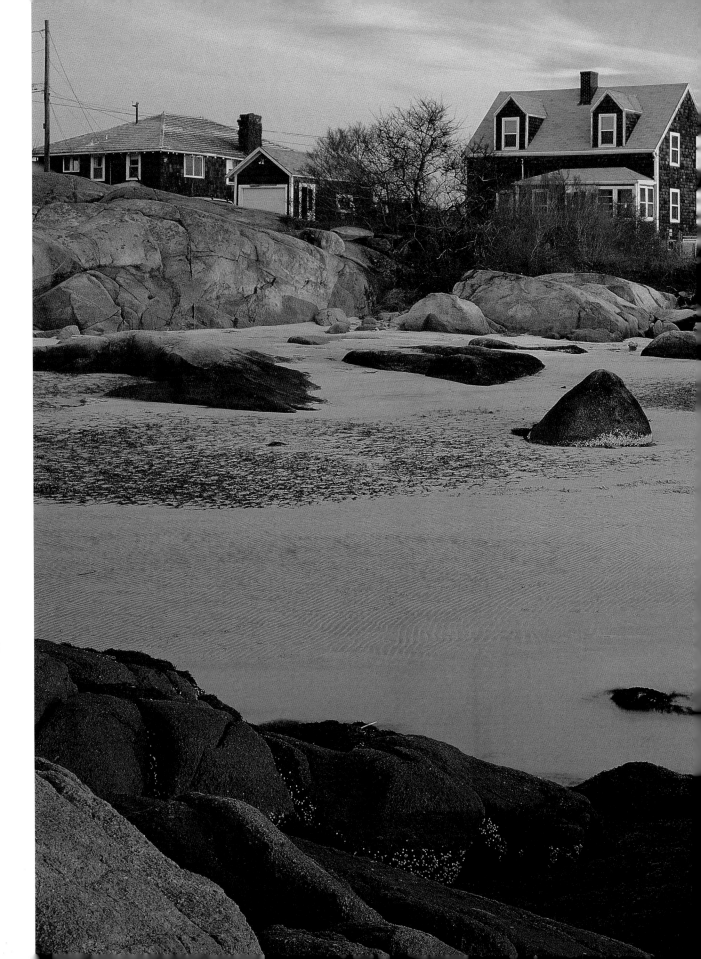

A beacon on
Wigwam Point has
been directing vessels
into Annisquam
Harbor since 1801
and the nearby
keeper's quarters
date from that time.
The present brick
lighthouse was built
in 1897.

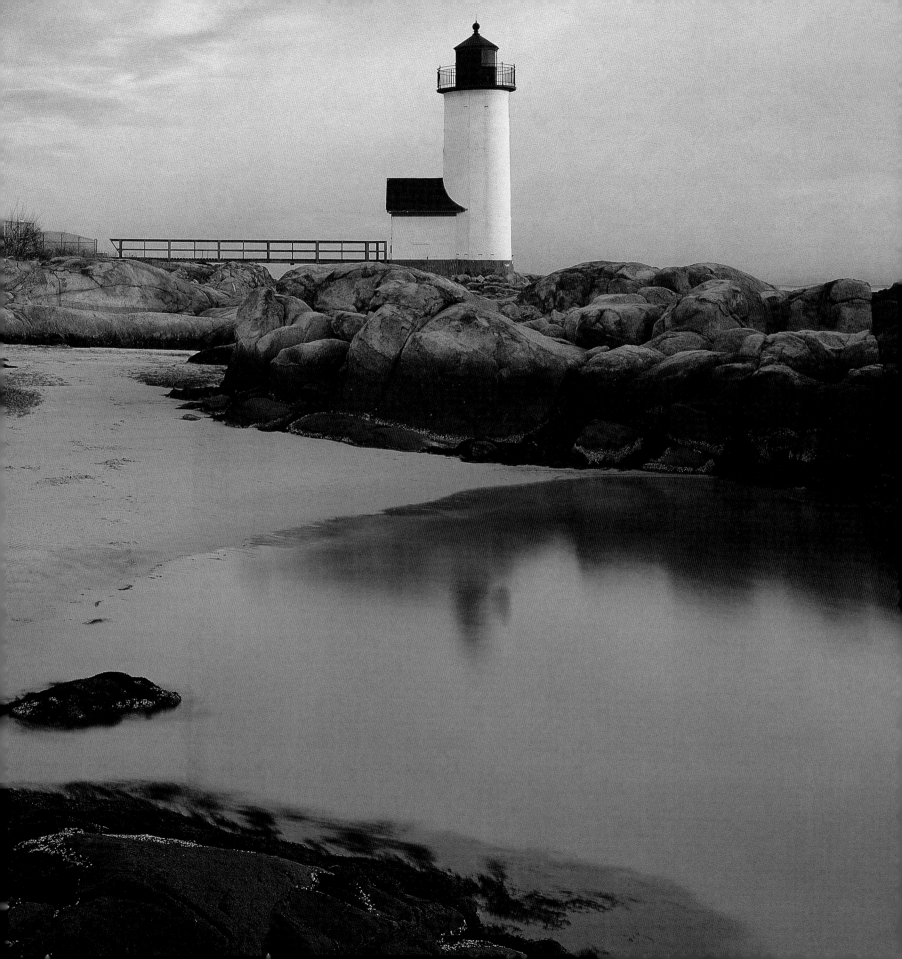

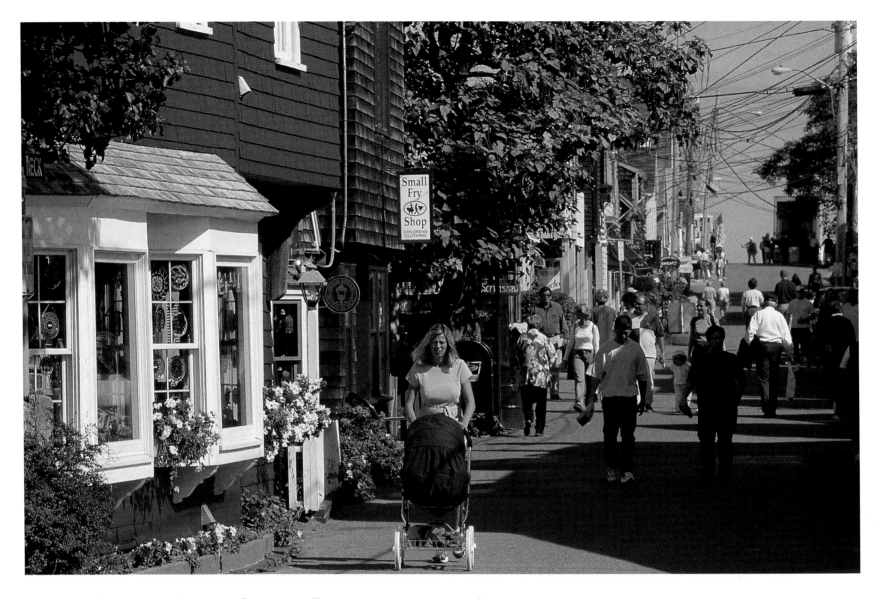

Rockport has more than 100 fine art galleries, quaint inns, and bustling gift shops, combined with the atmosphere of a sleepy fishing village. One of the colorful lobster shacks is so popular with artists it has earned the name Motif Number 1.

The history of Rockport, perched on Cape Ann's northern tip, is based in granite. Numerous quarries and granite outcroppings are scattered around the town.

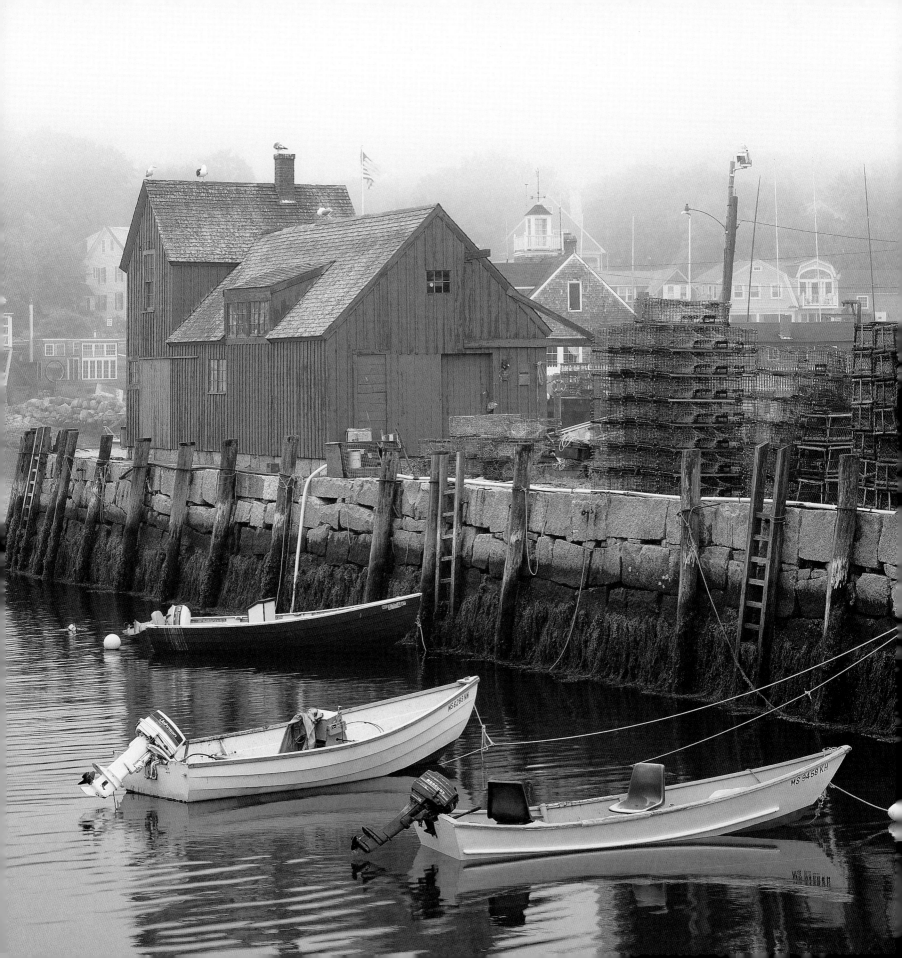

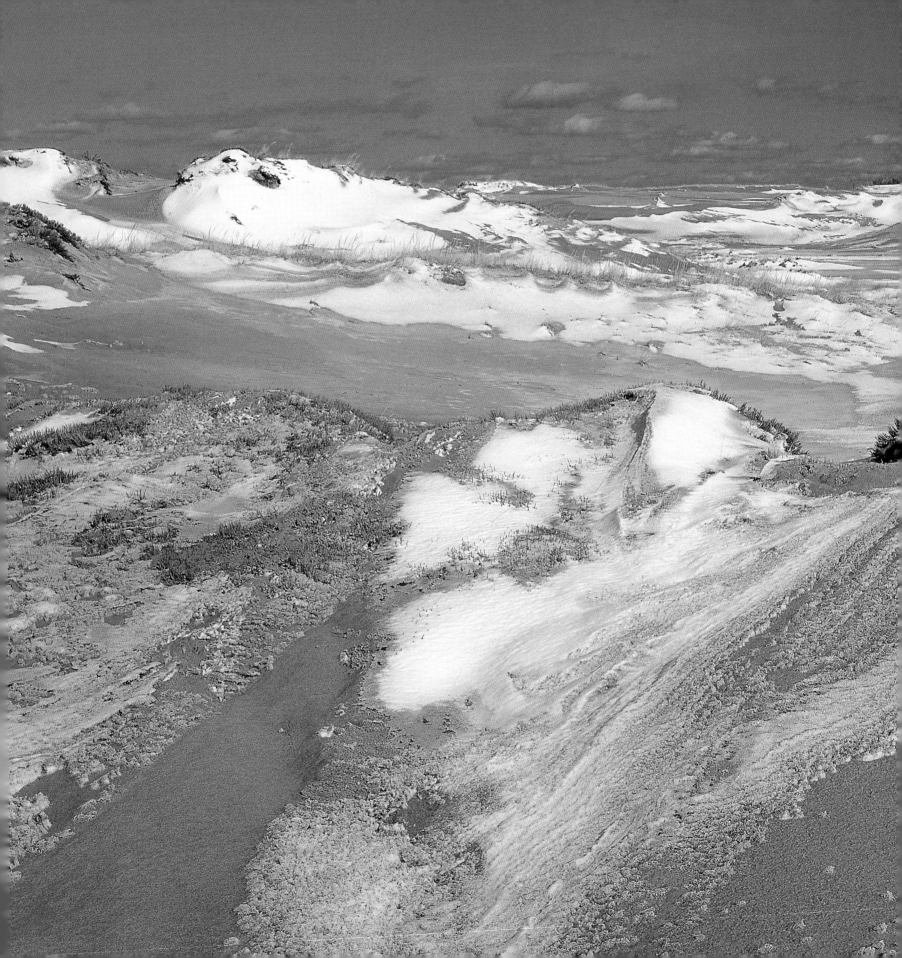

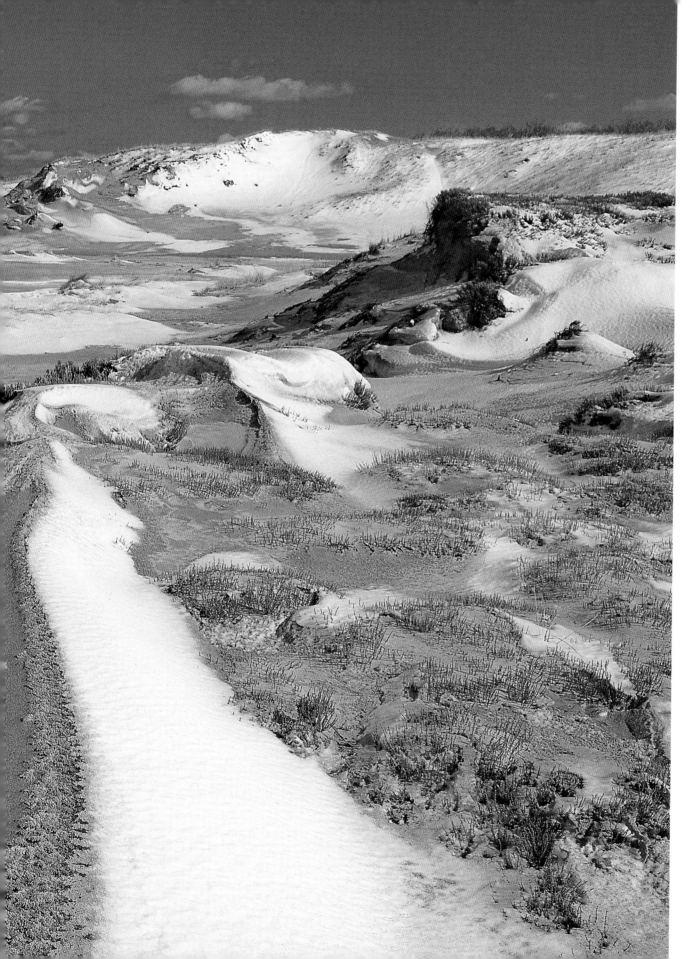

One of the most popular summer retreats in New England, Crane Beach shows a different side in winter, when drifting snow creates patterns on the silent dunes. Nearby, the Crane Wildlife Refuge shelters thousands of migrating birds.

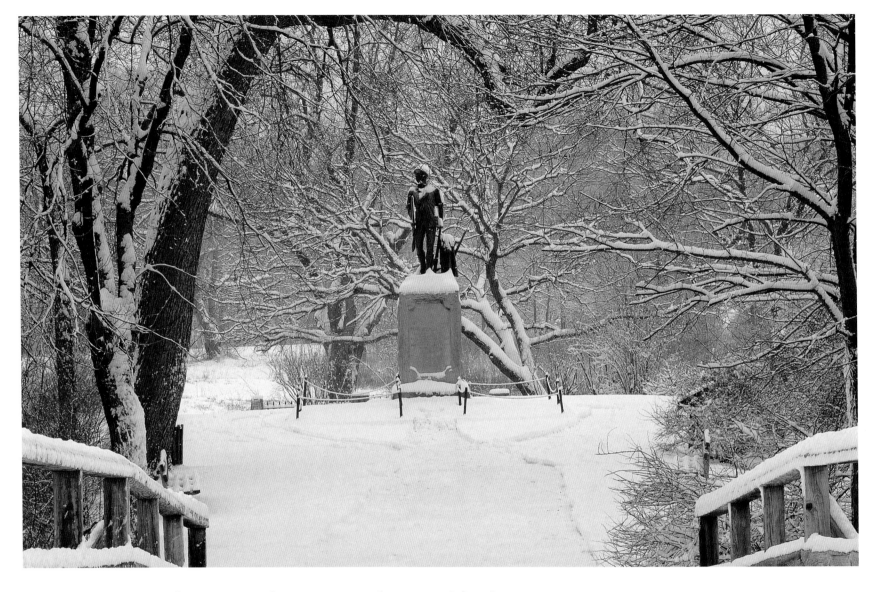

Minute Man National Historic Park near Concord is named for the
American militia – known as minute men – in the Revolutionary War.
The conflict here between the militia and British soldiers on April 19,
1775, set the stage for the war.

Now a national historic landmark, Walden Pond was the home
of Henry David Thoreau from 1845 to 1847. The area inspired
his book *Walden*, which helped spark the environmental
conservation movement.

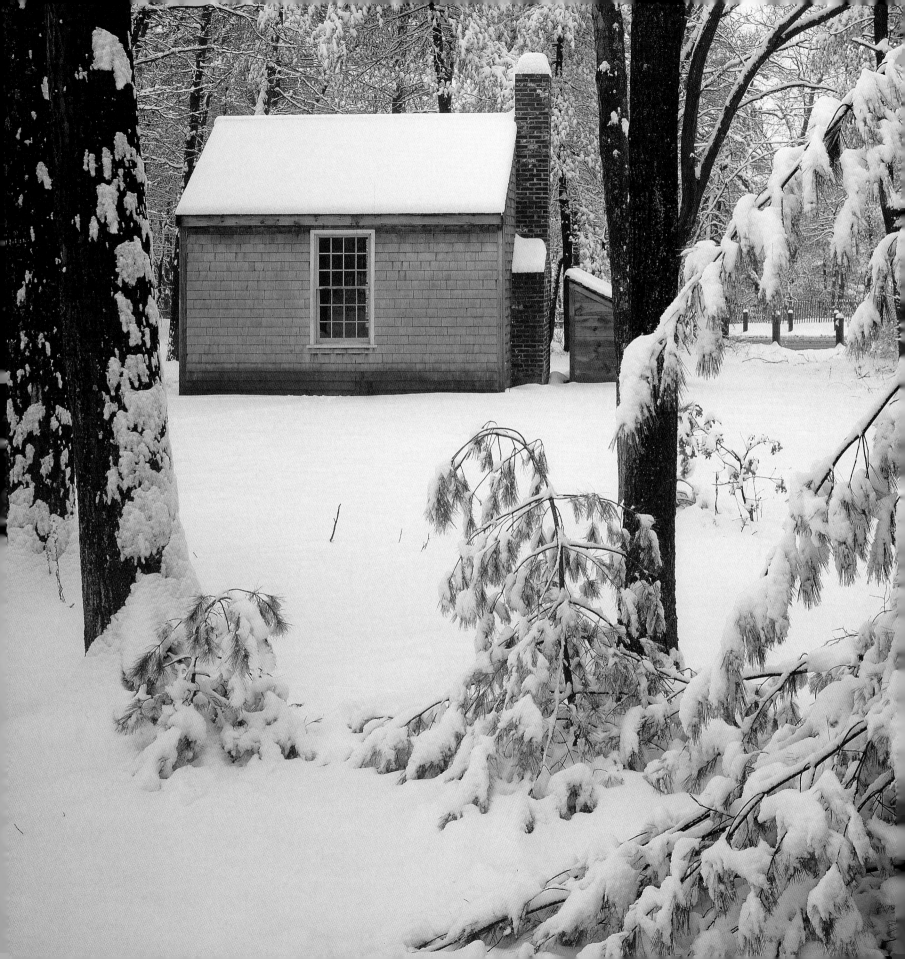

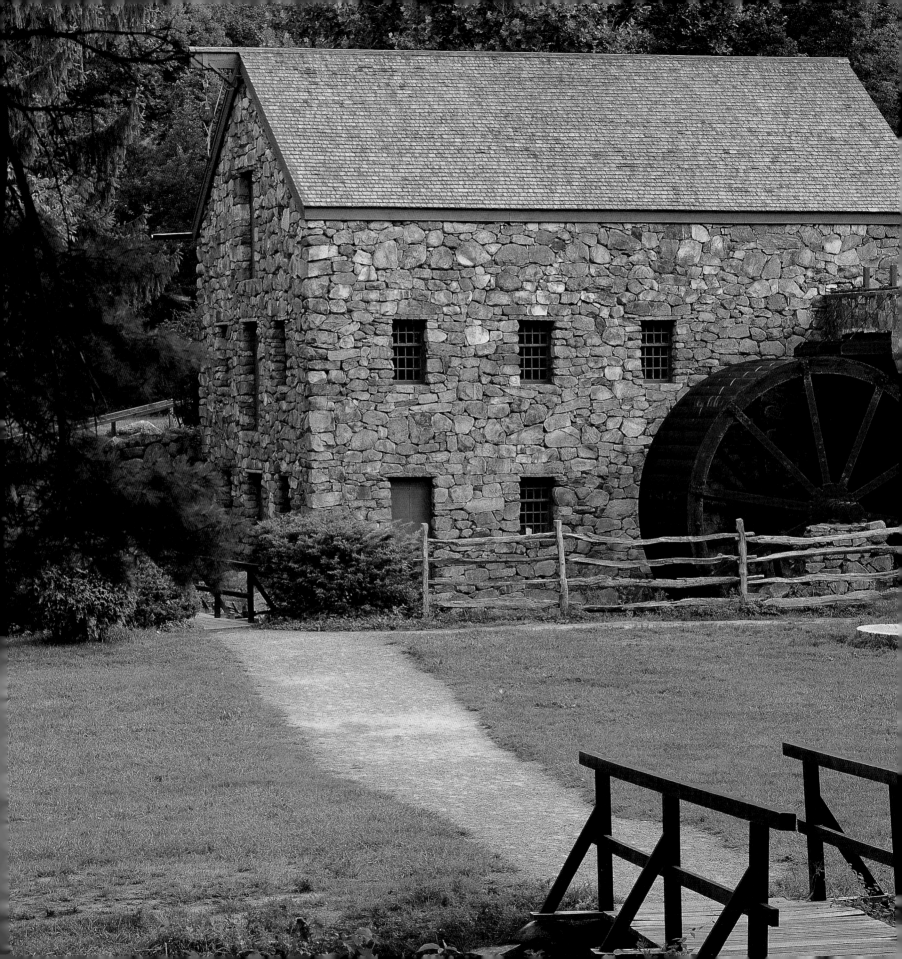

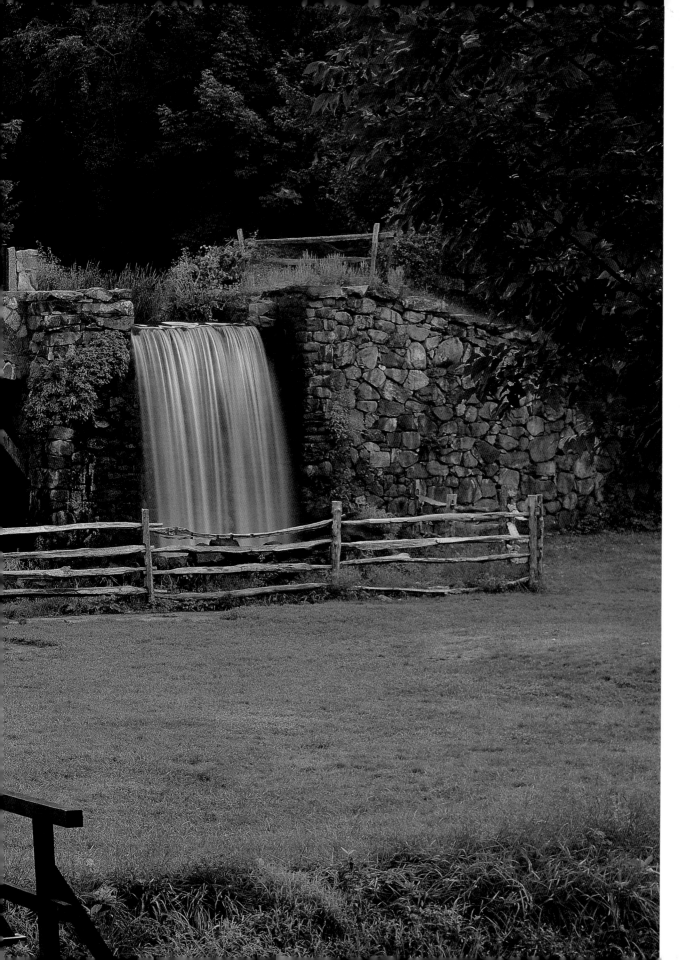

The Wayside Inn in Sudbury inspired Henry Wadsworth Longfellow's book *Tales of a Wayside Inn*. Built in 1716, the inn has 10 guest rooms and a restaurant serving traditional New England meals.

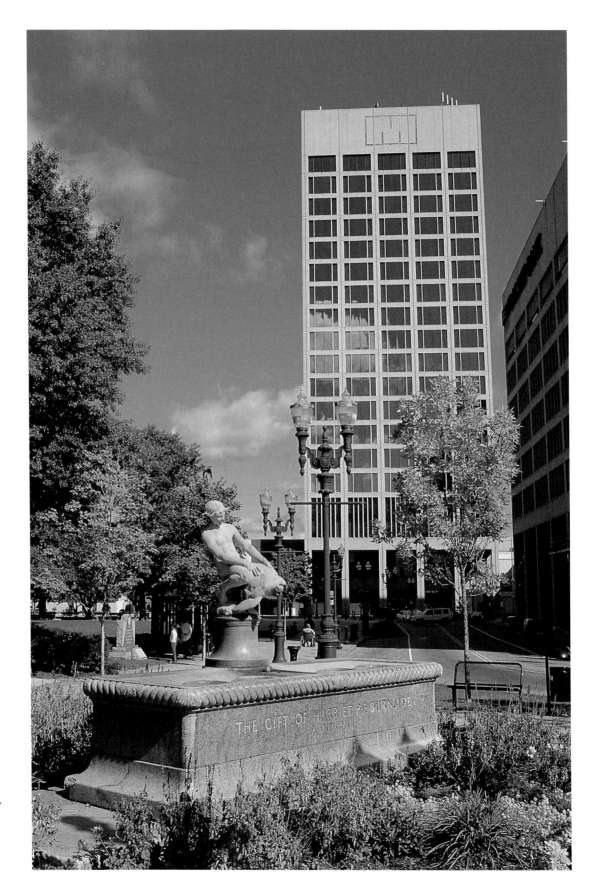

The second-largest city in New England, Worcester has been a center for industry throughout Massachusetts' history. One of the city's most popular attractions is the Higgins Armory Museum, founded after the president of the Worcester Pressed Steel Company toured Europe to buy ancient metal armor.

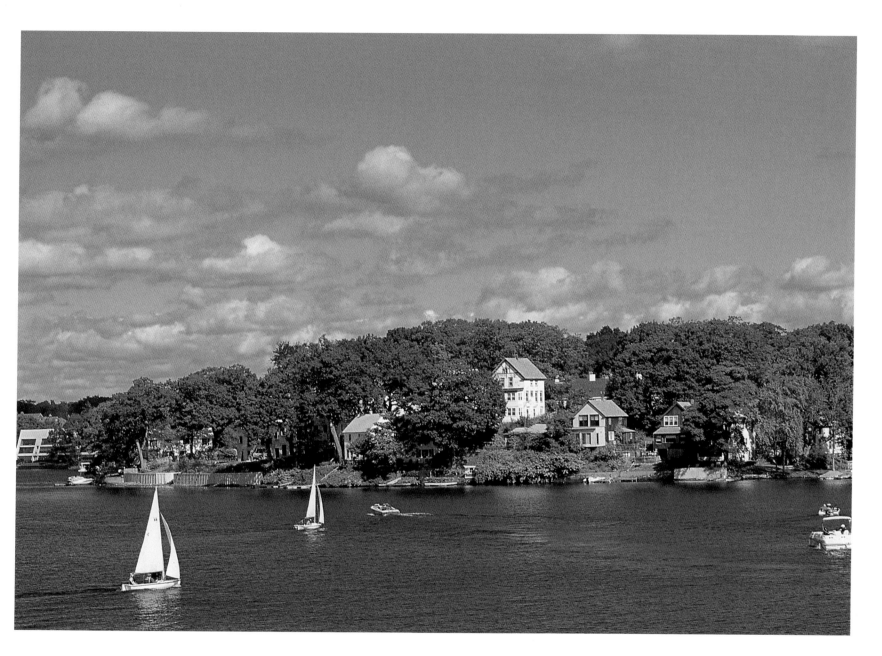

Vessels unfurl their sails on Lake Quinsigamond near Worcester. The lake is best known as a rowing venue, with an internationally recognized 2,000-meter competition course.

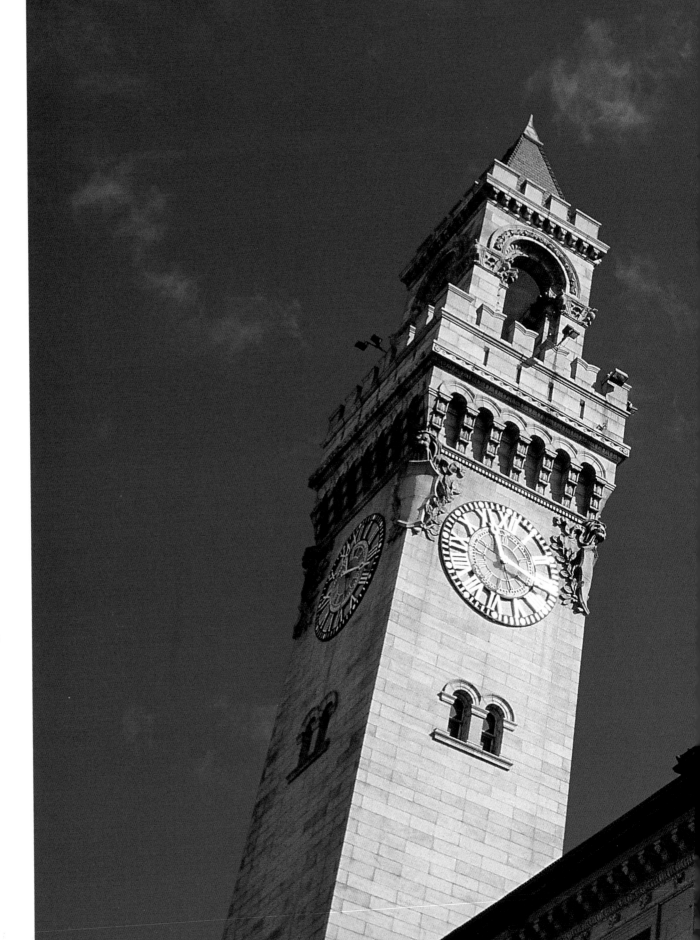

Built in 1898, Worcester's City Hall towers 205 feet above the street. The Renaissance Revival-style building is mainly granite, bedecked with several carved lions and a carved eagle above the main entrance.

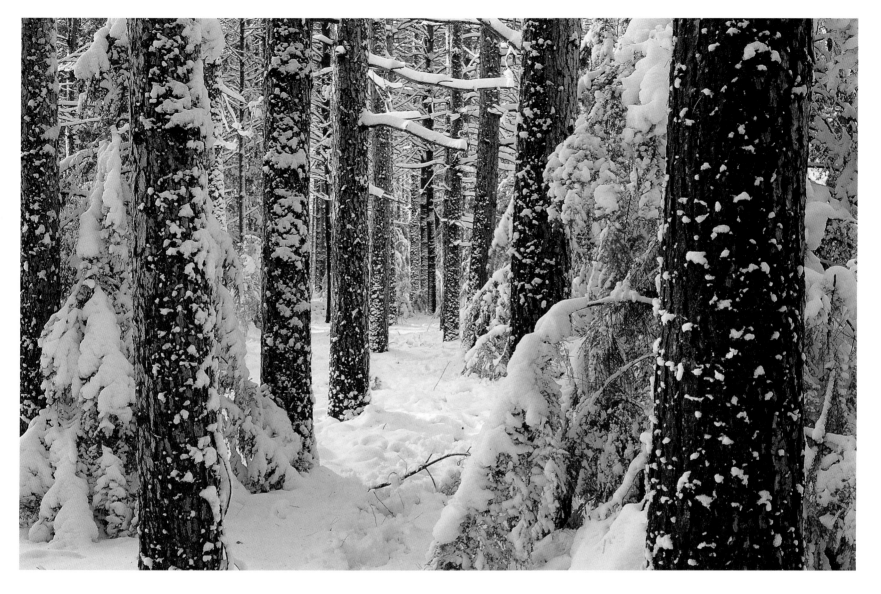

The Quabbin Reservoir, named for a native word meaning "land of many waters," supplies water for more than 2.5 million Boston residents. The land surrounding the reservoir is a pristine watershed offering respite to both wildlife and visitors.

Founded in 1810 and named for William, Prince of Orange, the land around Orange, Massachusetts, has drawn both farmers and industrialists. Grout automobiles were manufactured here in the early 1900s.

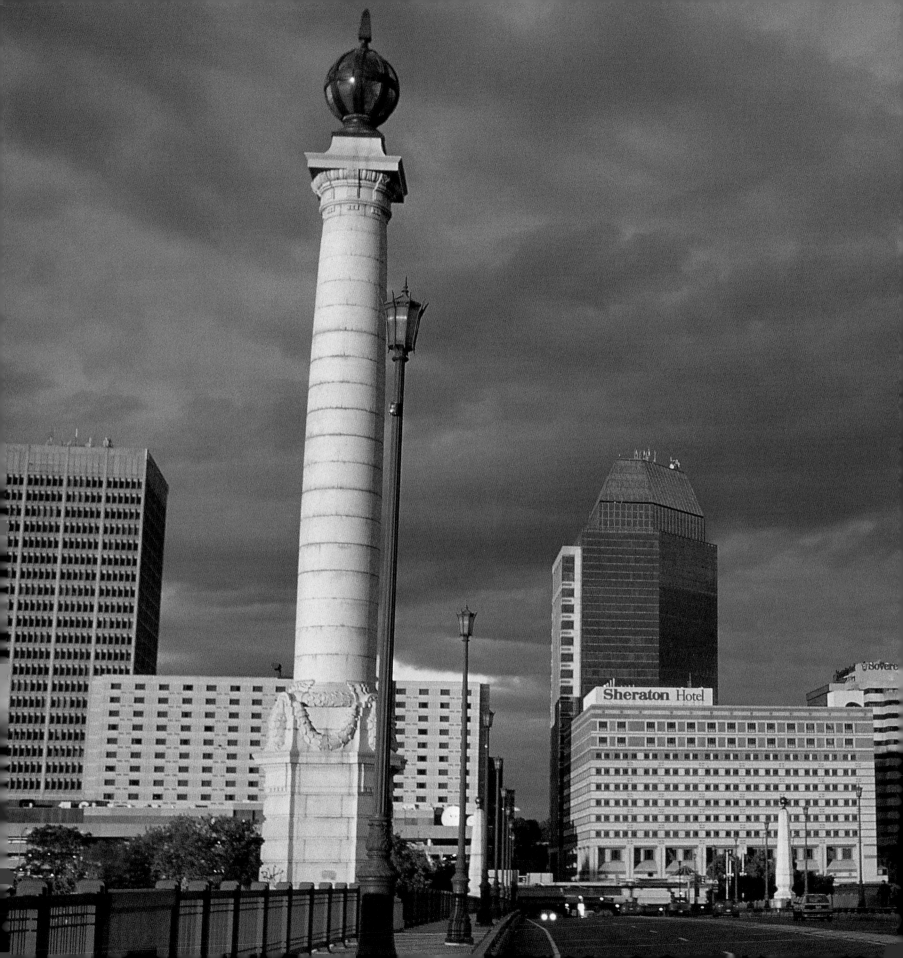

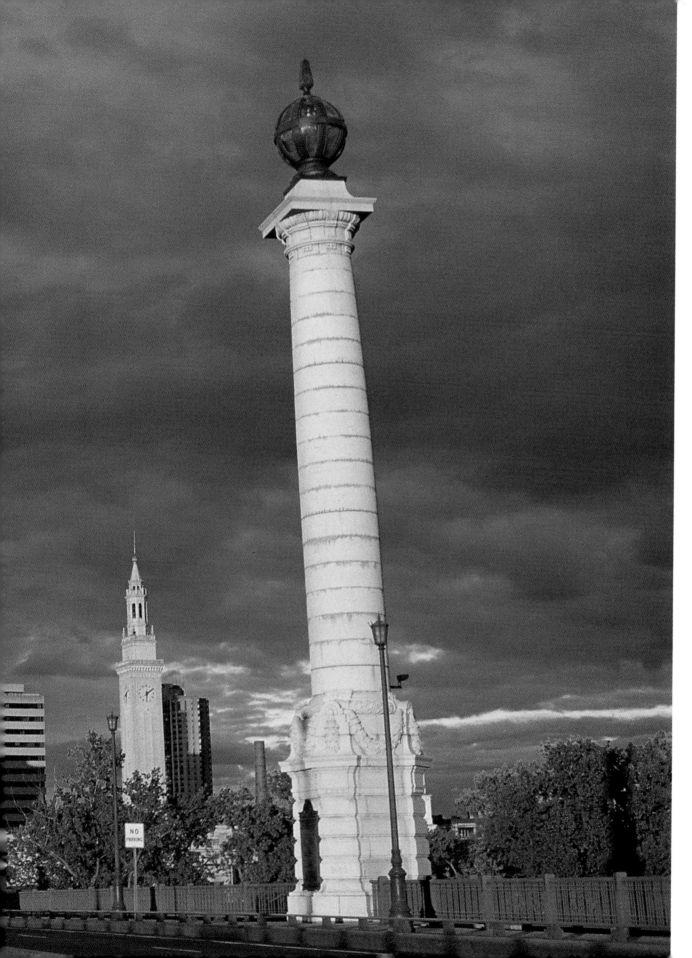

With three million square feet of office space, Springfield is one of the state's primary commercial centers. Graduates from 24 post-secondary institutions in the area help provide the work force.

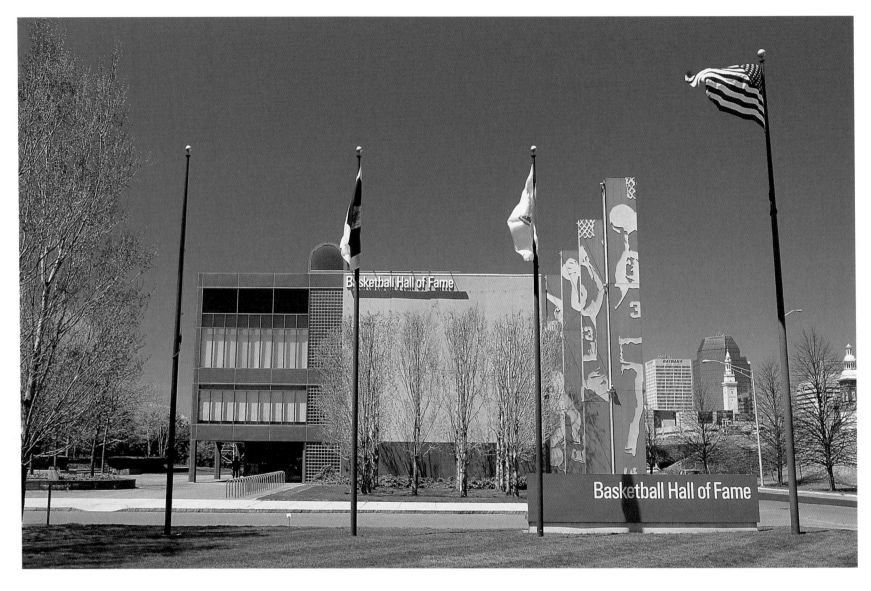

The Naismith Memorial Basketball Hall of Fame in Springfield is named for the founder of the game. It opened its doors in 1968 and attracted more than 100,000 visitors in its first year. Attendance has almost doubled since.

Shelburne Falls tumbles into a deep pothole, ground by the rushing meltwater of the last ice age. At 39 feet in diameter, this is the largest of many potholes along this stretch of the Deerfield River.

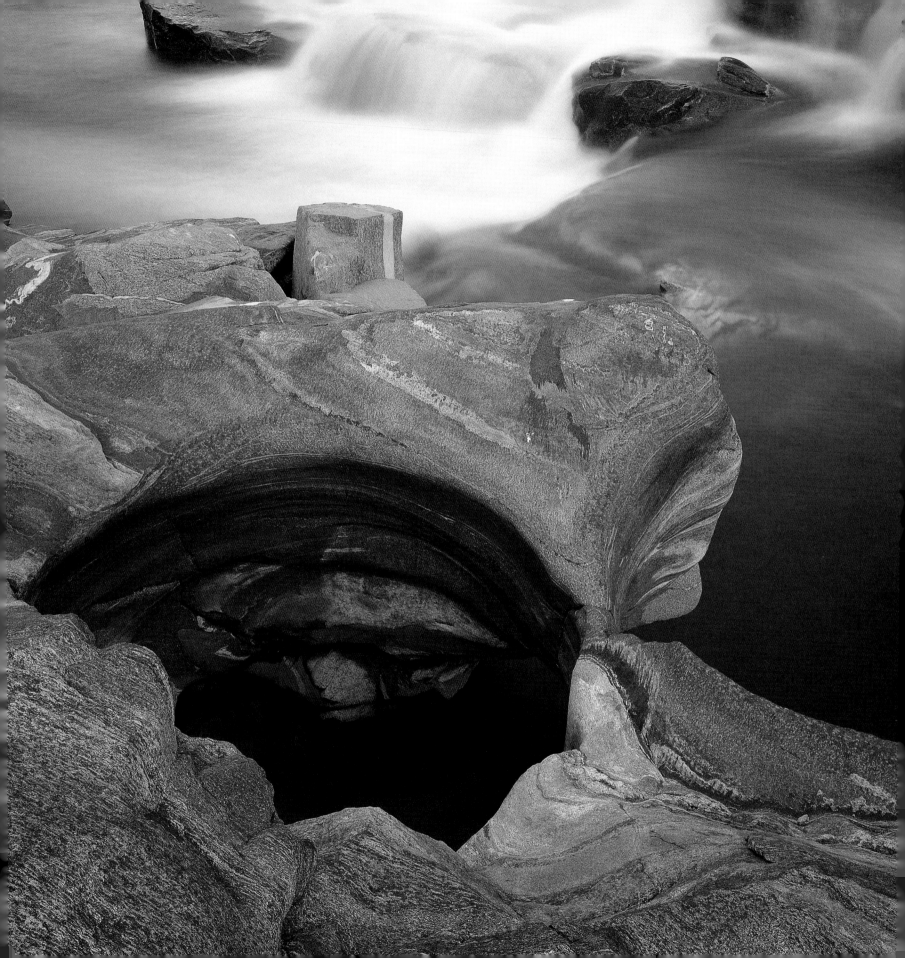

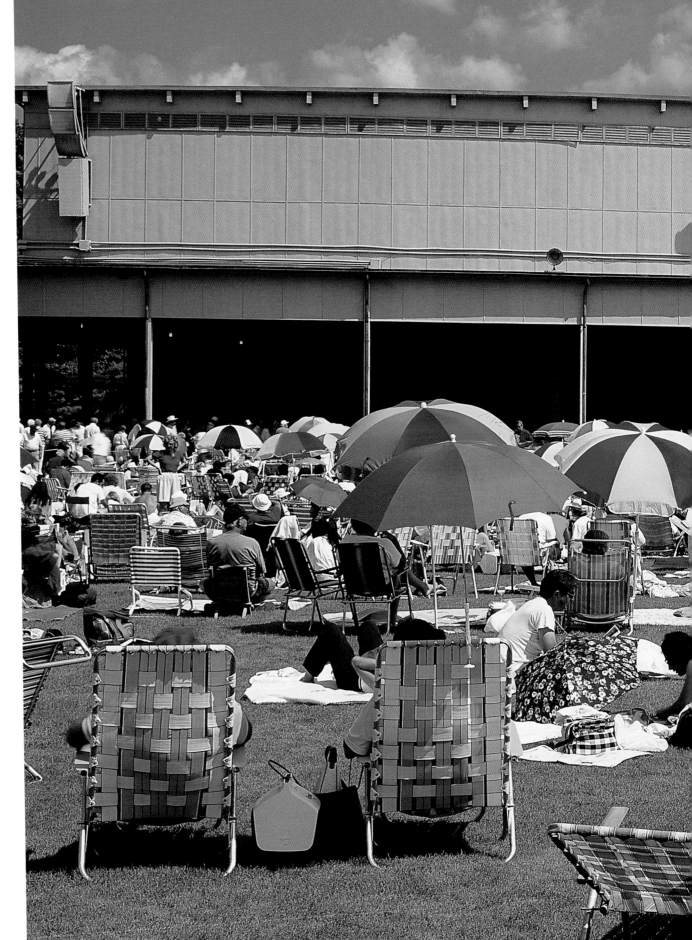

The Boston Symphony Orchestra moves to Tanglewood each summer, offering classical music under the peaks of the Berkshires. In addition to the symphony performances, summer events include jazz concerts, chamber music, and contemporary shows.

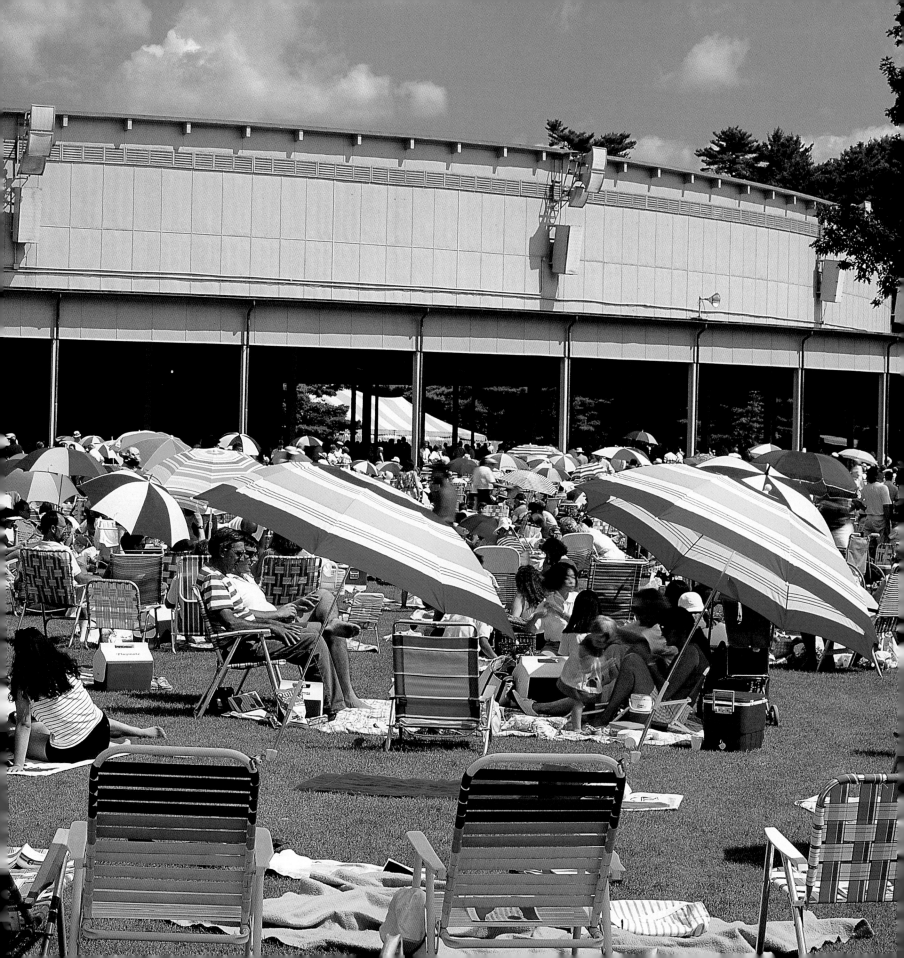

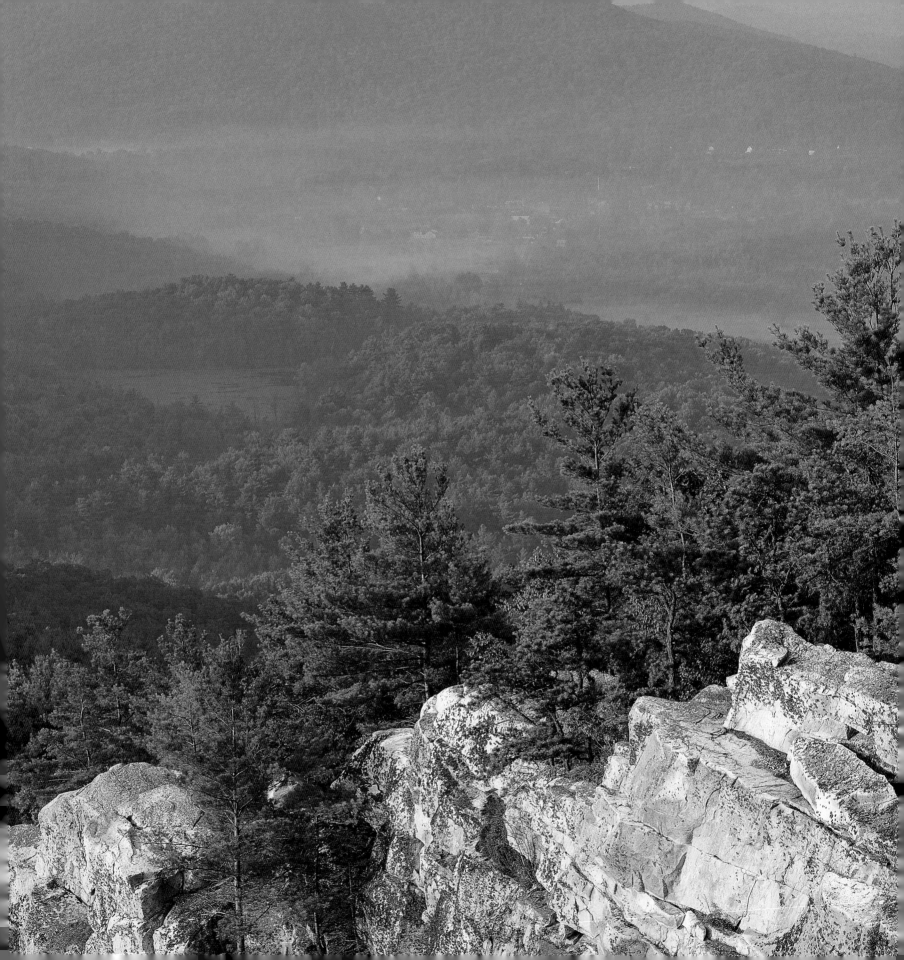

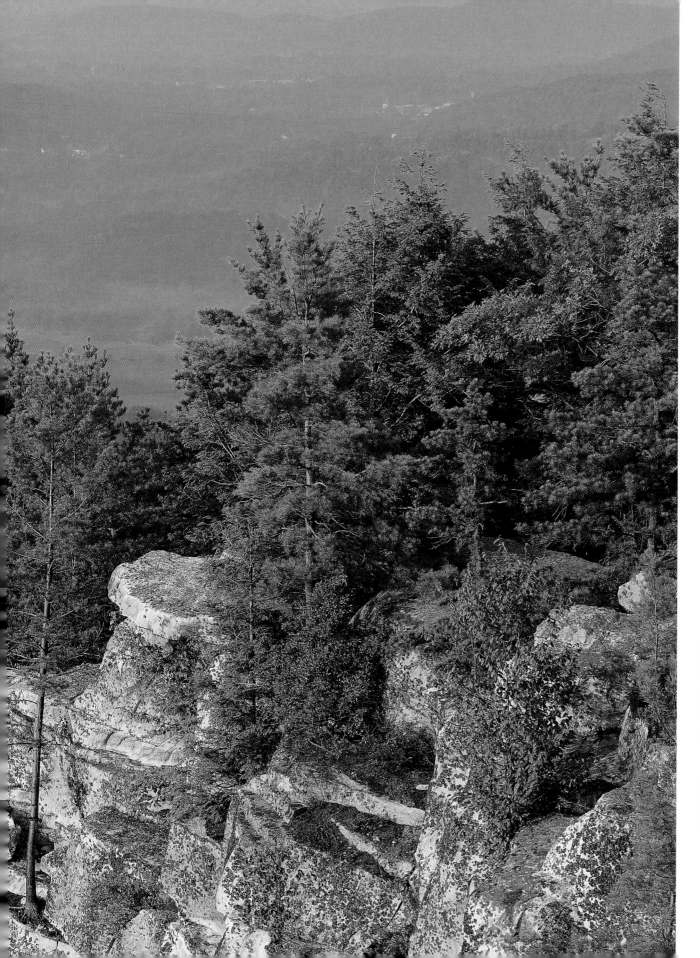

Quartzite spires give Monument Mountain in the southern Berkshires its name. Looming 1,735 feet above sea level, the mountain is a favorite hiking destination.

85

Massachusetts wildlife officials have spent the last several years working to reintroduce rare species to the state. Some, such as bald eagles, are thriving in heavily forested areas. Others have chosen the urban landscape: several peregrine falcons nest on skyscrapers in downtown Boston and Springfield.

Picturesque winter scenes and flourishing summer gardens draw nature lovers to Stockbridge, a town that Norman Rockwell called "the best of America, the best of New England."

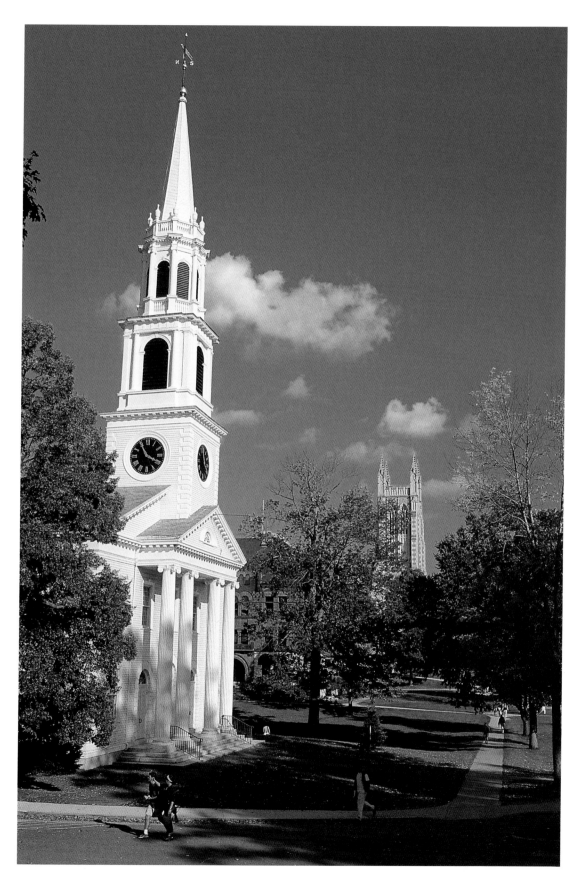

Nestled below Mount Greylock, the state's highest peak, Williamstown is home to Williams College. Sightseers make a special stop here for the college's art museum, which houses a number of original Impressionist paintings.

FACING PAGE—
While part of the Berkshires' appeal is outdoor recreation, part is pure grandeur, with ornate mansions overlooking the valleys, Victorian buildings lining the streets, and upscale galleries.

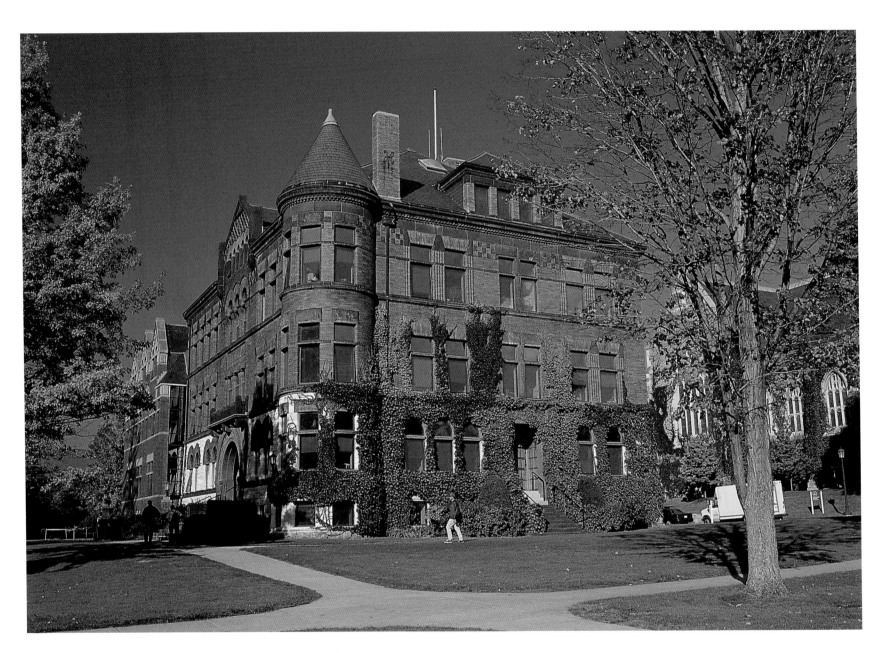

Williams College is named for Colonel Ephraim Williams, who was killed in battle in 1755 and left his fortune to establish a free school. The college has a unique admission policy – admissions are based solely on merit, and every student who needs it receives financial aid.

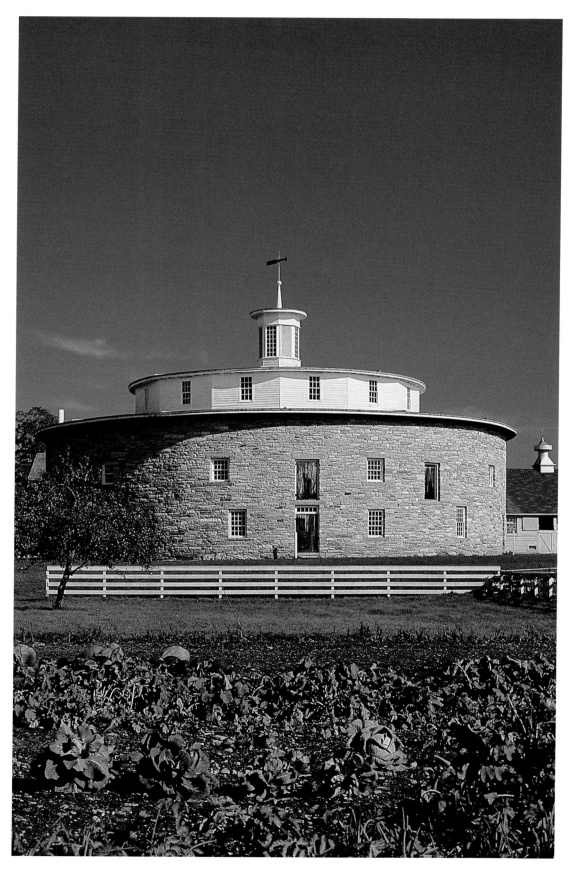

A historic village near Hancock commemorates the lifestyle of the Shakers, members of a religious sect who arrived in the mid-1800s and dedicated themselves to communal living, hard work, and celibacy. The village's collection includes early maps and drawings, furniture, sheet music, and clothing.

Hardwick has grown as an industrial town since 1686, when settlers bought the land from native people. Mining, logging, and the production of potash and charcoal employed many residents throughout the eighteenth and nineteenth centuries. Agriculture is a leading industry today.

In summer, the beauty of the surrounding mountains draws visitors and residents away from the Berkshire towns and into the woods, where impressive sites such as Whitmore Falls await.

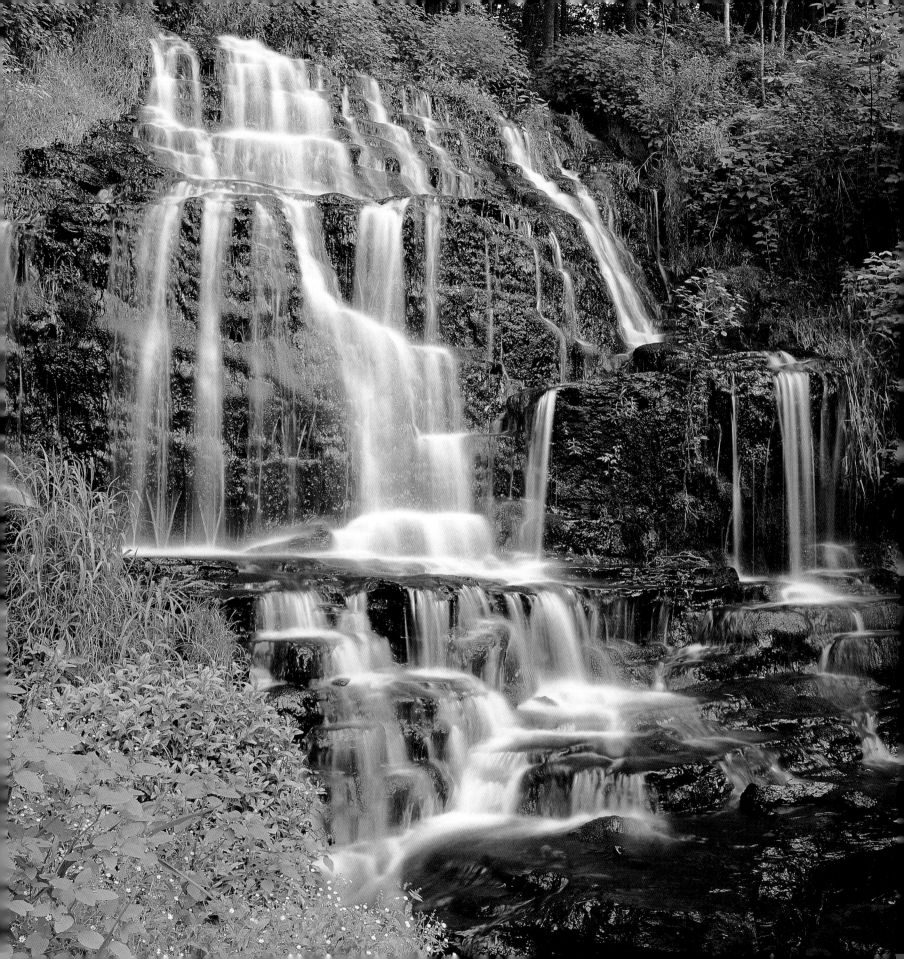

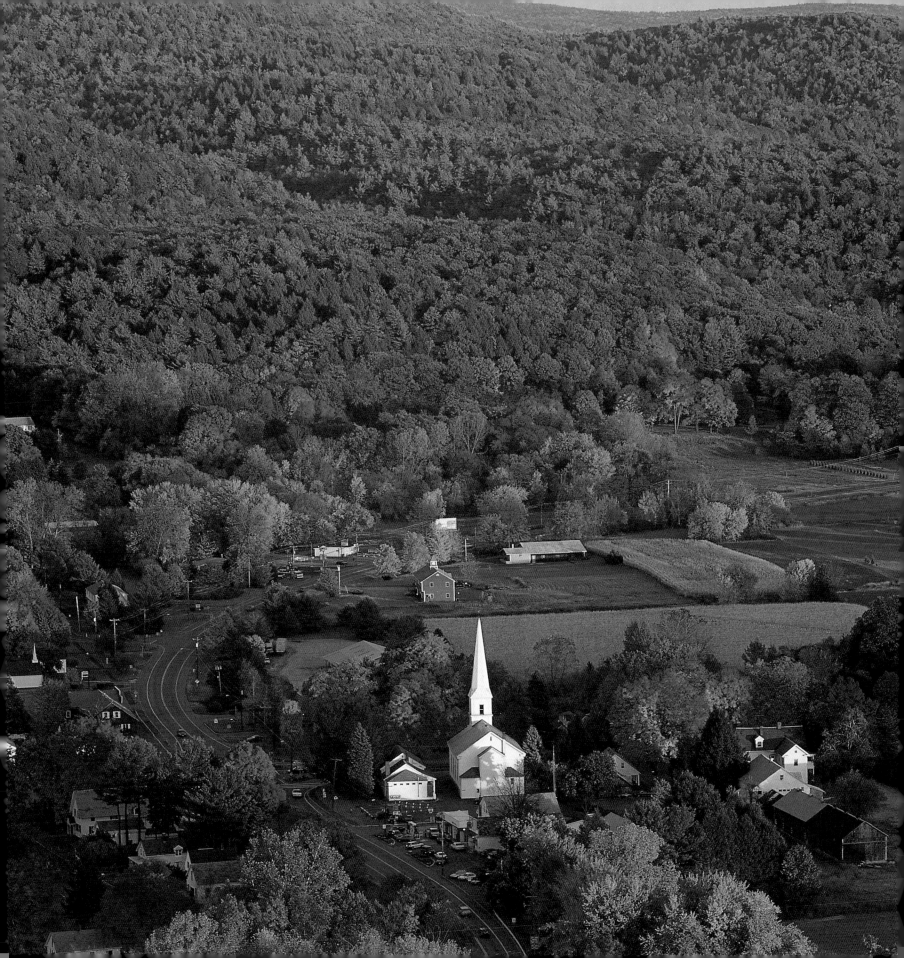

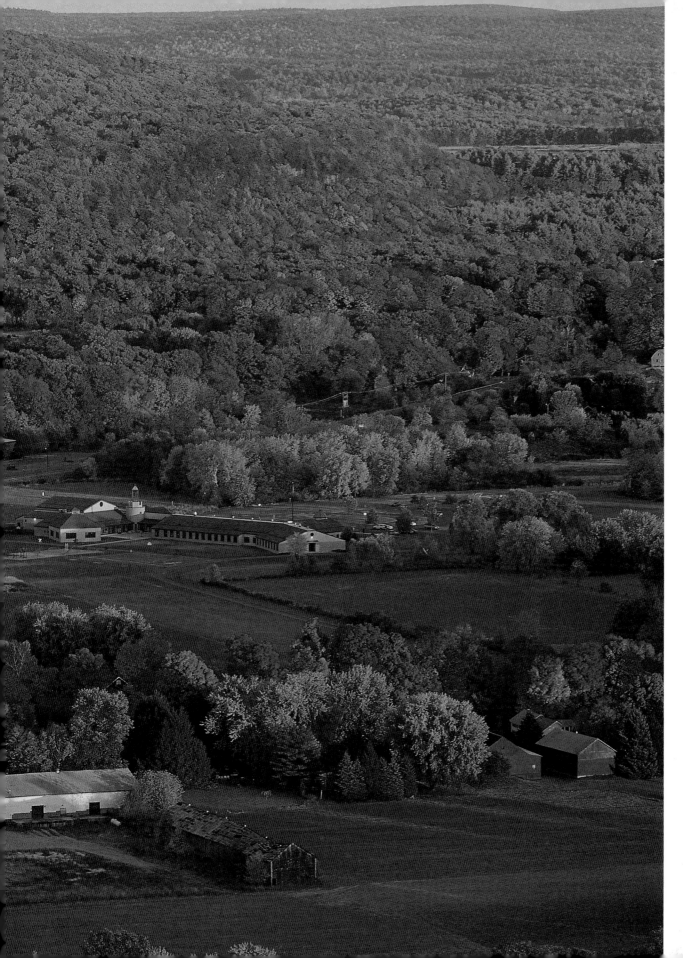

Dairy, tobacco, and vegetable farms surround the town of Sunderland, along with several maple sugaring operations. Historic homes, a stately city hall and library, and lush lawns and gardens also lure people here.

Photo Credits